12/93

APERTURE

Photographs by Olivo Barbieri, Gabriele Basilico, Letizia Battaglia, Ernesto Bazan, Gianni Berengo Gardin, Antonio Biasiucci, Anton Giulio Bragaglia, Velio Cioni, Francesco Clemente, Fabrizio Ferri, Luigi Ghirri, Mario Giacomelli, Paolo Gioli, Paolo Giordano, Piero Guerrini, Nanda Lanfranco, Mimmo Jodice, Fosco Maraini, Martino Marangoni, Paolo Monti, Davide Mosconi, Ugo Mulas, Franco Pinna, Armando Rotoletti, Mariell Russo, Ferdinando Scianna, Tazio Secchiaroli, Enzo Sellerio, Antonio Sferlazzo, Sergio S Oliviero Toscani, Giuliana Traverso, Franco Vaccari, Luigi Veronesi, Franco Z

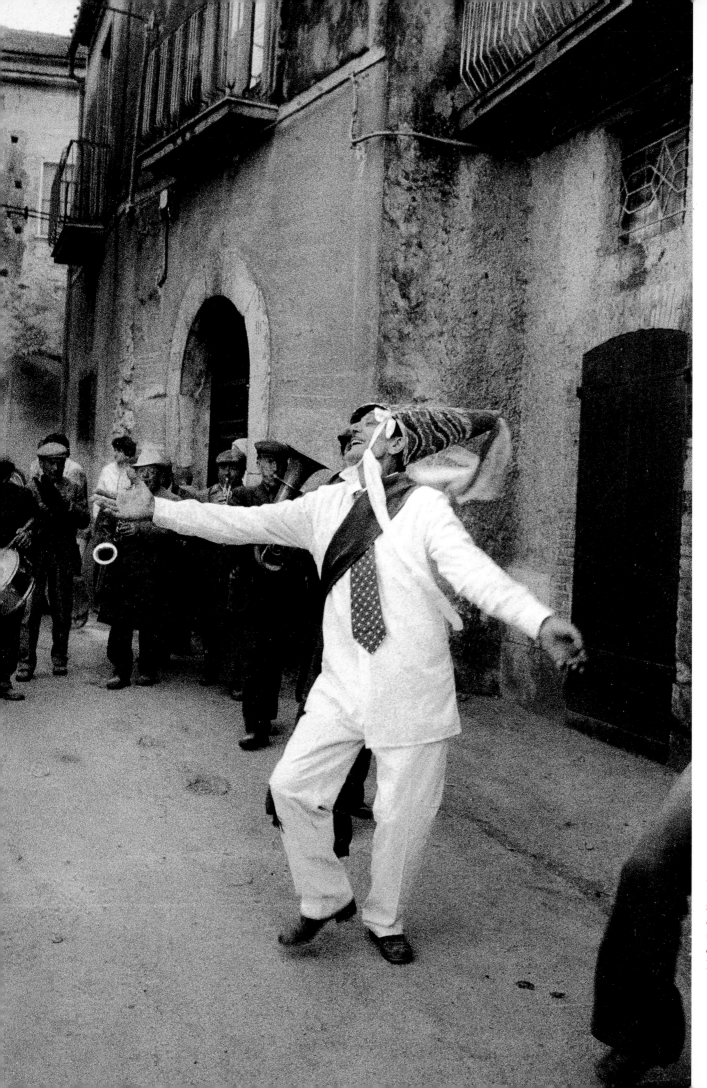

Marialba Russo,
Carnevale,
maschera
del Pulcinella
(Carnival,
costume of
Pulcinella),
1976

IMMAGINI ITALIANE

The term "Immagini Italiane" may evoke the various travels delineated by Goethe, D. H. Lawrence, Mark Twain, and others; or, one might envision Paul Strand's people of Luzzara; the Venice of Palladio and Canaletto, or Alfred Stieglitz's Venetian boy. Pictures of piazzas articulated by magnificent duomos, packs of tourists with umbrella-waving guides, landscapes—seductive, verdant, timeless, surreal, Felliniesque—all come to mind. And so do images of the Italians themselves, careening on motorbikes, enjoying the requisite *passeggiata*, on strike, or—as occurred last May in Florence—gathered in solidarity against terrorism. For many, however, the appellation "Italian images" will not immediately suggest photographs by Italian photographers.

While Italian artists working in other media are touted as visionaries, Italian photography remains virtually unviewed. Yet there are countless compelling and innovative Italian photographers exploring and working in all genres. The revelation of Italian photography, the experience of Italy as seen through the sensibilities of its own photographers, and Aperture's mission to publish work with which our audience may not be familiar—these are the forces that fueled "Immagini Italiane."

There is a small group of profoundly committed writers and curators who have come to act as advocates on behalf of the photographers, and without whom the circumstances in Italy for photography would be practically untenable. The devotion of those who have dedicated themselves to creating a place for photography in Italy has made the process of putting together "Immagini Italiane" feasible, as well as celebratory. We are grateful for the generous collaboration and advice of Lanfranco Colombo, founder and director of Il Diaframma—Kodak Cultura in Milan (Italy's first exhibition space solely for photography), who made sure that we cast our net as broadly as possible, and who put his vast archive and wonderful staff at our disposal.

We also deeply appreciate the ideas and challenges put forth by many of the writers published in this issue and we thank them for the depth of their involvement, attention, precision, and care, and for their indispensible collaboration.

Germano Celant, Curator of Contemporary Art at the Solomon R. Guggenheim Museum, kindly offered his input, as did Luisella d'Alessandro, Denis Curti, and Daniela Trunfio of La Fondazione Italiana per la Fotografia (under whose auspices the Biennale Internazionale di Fotografia will be presented in Turin this fall); Italo Zannier, professor of the history of photography at the University of Venice; Alessandra Dragoni and Michele Neri of the Grazia Neri agency in Milan; and the group at Fratelli Alinari in Florence.

Aperture's exhibition of "Immagini Italiane," at the Peggy Guggenheim Collection in Venice from August 31 to November 2, 1993, resulted from the enthusiastic and gracious collaboration of the collection's deputy director Philip Rylands, and his assistant Renata Rossani, and from the vision of Isabella Rayburn and Ray Merritt of the Murray and Isabella Rayburn Foundation, great friends and generous supporters of photography and the arts.

After Venice, "Immagini Italiane" will travel to the Museo Pignatelli in Naples, where it will be presented from November 15 through early January 1994, under the auspices of the Soprain-tendenza per i Beni Artistici e Storici di Napoli and Incontri Internazionali d'Arte, founded and directed by Graziella Lonardi. For organizing this venue, and for her commitment and assistance to this entire project, we thank Pieranna Cavalchini of Incontri Internazionali d'Arte.

The show will travel to New York City in late January 1994, where it will be exhibited at the Murray and Isabella Rayburn Foundation, launching its United States tour.

Finally, *Aperture* thanks all the photographers who shared their images with us. While preparing this publication, we reviewed many superb and diverse bodies of work—far more than we could include in these eighty pages. "Immagini Italiane" has been an exhilarating process for us, and *Aperture* looks forward to publishing more work by Italian photographers in future issues.

Con amicizia,
The Editors

DEL BENE E DEL MALE

OR, WHO'S ON TOP?

BY LINA WERTMULLER

The media is full of sex. There is an outpouring from all directions—famous pundits, important journalists, sociologists—all the jungle drums of our global village. A recent echo came in the form of the hype surrounding the film *Basic Instinct*. The Roman theaters were packed with boys and girls with bated breath, lured by the call of a shrewd advertising campaign: "She crosses her legs provocatively in front of him, and she's not wearing any panties." It turned into an event, and the press, eager to become involved, has willingly gushed torrents of words about this most basic instinct.

Indeed, a year doesn't go by without the search for a scandal that can unleash commentary from the press, all directed at poor Eros, the rosy, malicious little putto who in this past century has found it increasingly difficult to let fly his scandalous arrow to bring about what the Neapolitans familiarly call "the mess."

The past year, chock-full of corruption on all levels, provoked countless diatribes on these messes. The press, determined not to disappoint its readers, fleshed out pages of political scandals, corporate kickbacks, fratricidal wars, economic recessions, arrests of business moguls, and crises of values with evocative images about the age-old problems of sex, nudity, attachments, connections, limits, liberties, and worthy indignities.

But the relationship between sex and politics is less frequently addressed. Politics, the just organization of the city, of the polis, of society, has an even longer and more complex history than sex, if that is possible. Over the centuries, dishonesty, violence, blood, ferocity, betrayals, dreams, ideals, hunger, death, injustice, and misery have been fodder for all human activities involved with the organization of society. Indeed, politics has been the alternative and substitute weapon for the sword, used to achieve the peak of human pleasure—dominion.

Power: now here is something that brings a gleam to men's eyes. Power, more than Venus, who has only moistened the corners of men's mouths with the dribble of desire. It is Power that has kindled the imagination of all the crazy and ambitious megalomaniacs who have moved through the complex history of the human species. There is a Sicilian proverb that says: "Cumannari i megghio ca cutteri" (Being in charge gives more pleasure than making love). Indeed, in my opinion, there is a subterranean connection, stronger than one suspects, between the two things. In politics, as in love, there is always someone on top and someone below, someone in charge and someone who obeys, someone who wants to be the master and make you a slave. And someone who wants only a

Gianni Berengo Gardin, *Milano, servizio fotografico, pausa di lavoro* (Milan, photographic service, work break), 1987

wicked dominator to give orders, making you feel like a humiliated servant. Sadists, masochists . . . erotomaniacs of all types. And you can't rest easy, there's something of all of them in each of us.

When we see political figures who court the crowd, speaking with an unbridled, desperate desire for power that equals pleasure—now strong, now sweet, now lucidly rational, now impassioned and lyrical—the analogy of seduction and mental eroticism is clear. Once, the anecdotes that accompanied the histories of dictators tended to describe the mass—the true object of desire—as a female to be penetrated; and the woman—seen as a prize, as a sugarplum—was set aside for the warrior's relaxation. There is a famous, and true, story about Mussolini. One day, orating from the balcony of the Palazzo Venezia, he proclaimed that Italy again had an empire. He then returned inside, followed by the echoes of cheers from the oceanic crowd. In his private sitting room he found a certain Signora Petacci, mother of the young Clarette, and, still dewy and shining from the applause of thirty million Italians, he asked her, "Signora, may I love your daughter?" A question to which the embarrassed Signora Petacci clearly could not respond: "But how can it be permitted, with you married and with a big family?" The most bourgeois of mothers will never be able to muster the courage to deny anything to a founder of empires. The truth is that, in the heads of human beings, the true, real, comprehensive rapture of ejaculation and the sound of bells occur through the most metaphorical forms but are always tied to the most hidden mysteries of the ego.

In my films, without even being aware of it, my small, dark men, who embody the Third World of society in search of some dignity and security, always have a fragility, in contrast to the more solid, more conscious "first world" women. The lumpen proletariat and the bourgeoisie are an old couple who have a long history of hatred and love, very erotic and always full of possibility, despite the dissolution of barriers and the confusion that has resulted. The disappearance of the socialist paradise and the collapse of utopias, attempted in vain so many times in this century, don't in the least diminish the coalition of contrast and desire wherever poverty and wealth are juxtaposed. On the contrary, these two faces of society still have a future full of unforeseen, inevitably erotic adventures. Perhaps in these times more nightmares populate the nights of the great democracies. And yet that tension always ends up, sooner or later, in great moments of love.

Gianni Berengo Gardin, *Venezia, il Lido,* 1958

Today, confusion confounds desire. The quantity, the culture of violence, of transgression, of special effects, of electronics, of drugs, of AIDS, have blurred over the legible landscape of clearly contrasting lights and shadows. The breakup and the crumbling of empires, of countries, into a multitude of small, ferocious blocs; these strange wars; the history of Beirut and of Lebanon, begun with such ferocity and then extinguished without clarity; Yugoslavia; ethnic rivalries—they all reek of a confusion as great as that of those San Francisco nights, with their fantasy kingdoms and sexual castes, or of the corrupt and confusing politics of newspaper pages in search of new, unexpected, and lascivious sexual emotions. Fragmented, cracked—the whole worldview. Even if it is, perhaps, precisely the disintegration of utopia that has brought us a rare moment of realistic awareness in the history of our culture.

Do you remember revolution? Or does the political confusion make it imaginable for a restaurant in, let's say, Munich, to accommodate at one table a Nazi skinhead with a swastika tattooed on his forehead, at another table a group of Jews with sidelocks, a small group of former KGB torturers next to a well-turned-out group of Mafia drug- and death-dealers? No. Thank God it's not like that. The world maintains the dichotomies of good and evil.

We have been preceded by infinite millennia of darkness and silence, and we will be followed by infinite millennia of darkness and silence. We have a half hour or so of sunlight to work up a good heat. Let's have chubby little Eros place his arrow in his golden quiver; let him strike human beings—disguised en masse as heroes, devils, and angels—in all their ardent moments. And let's hope that, with their allegories and dreams, people will still retain the small but extremely important comfort in that quotient of humanity that here, in your media paradise, manages to convey a sympathetic sensation of warmth. For in the end, this always reverberates back to the tender and candidly erotic warmth that existed—before sex, before politics—in the far-off cradles of our infancy. Paradise may seem more lost than ever, even the small human paradises—those that used to give meaning to life. And so we must seriously rethink life, yet again, as a battle between good and evil, and love as a scorching frontier that exists in that half hour of light we call human existence.

Translated from the Italian by Marguerite Shore

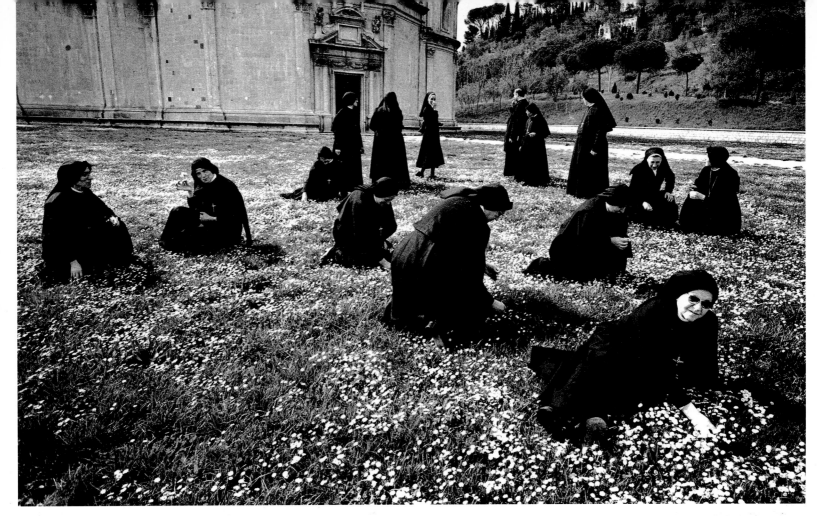

Above: Gianni Berengo Gardin, *Todi*, 1976

Below: Ernesto Bazan, *Marsala*, 1987

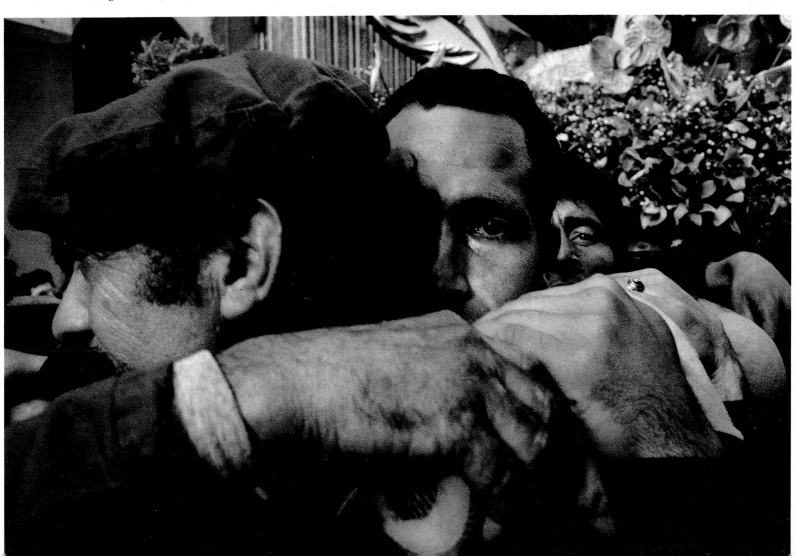

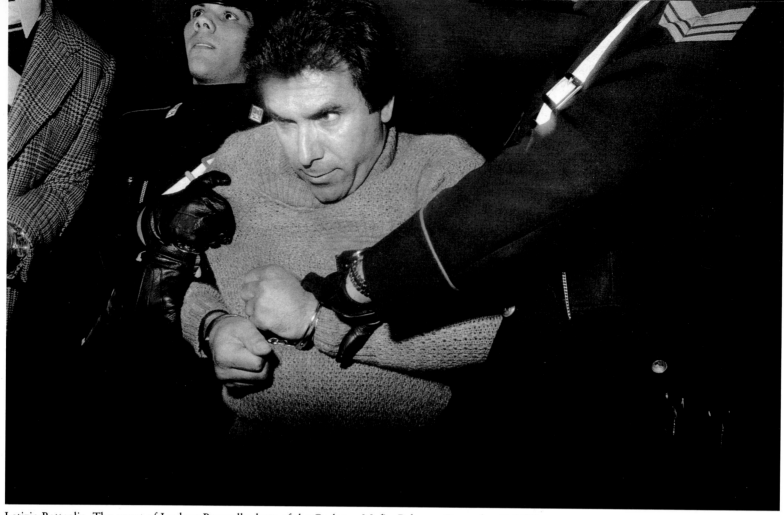

Letizia Battaglia, The arrest of Leoluca Bagarella, boss of the Corleone Mafia, Palermo, December 6, 1979

Franco Zecchin, Wife of Nino Badalamenti, mafioso murdered by a rival mafia, August 19, 1981

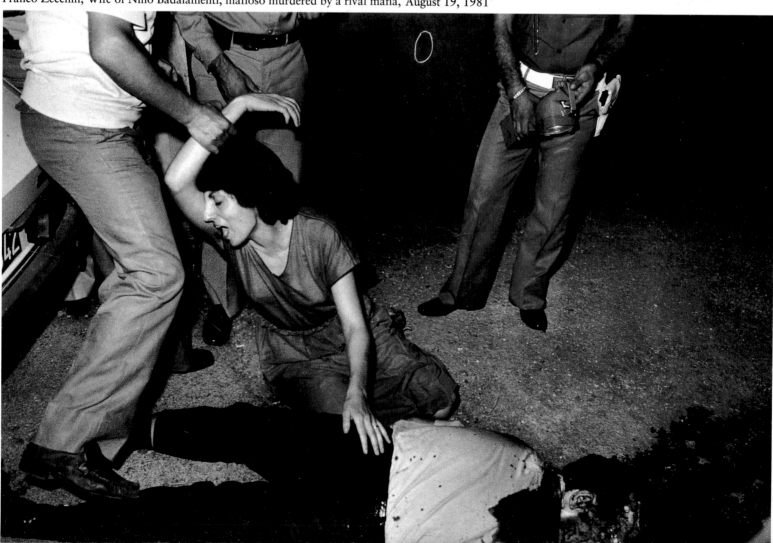

Armando Rotoletti, *Lorenzo cerbiatto di città* (Lorenzo fawn of the city), 1989

Giuliana Traverso, *Untitled*, 1992

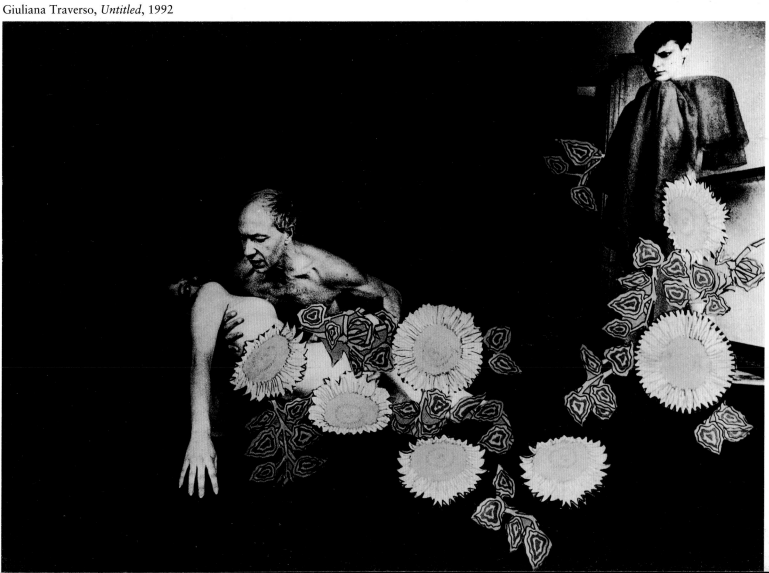

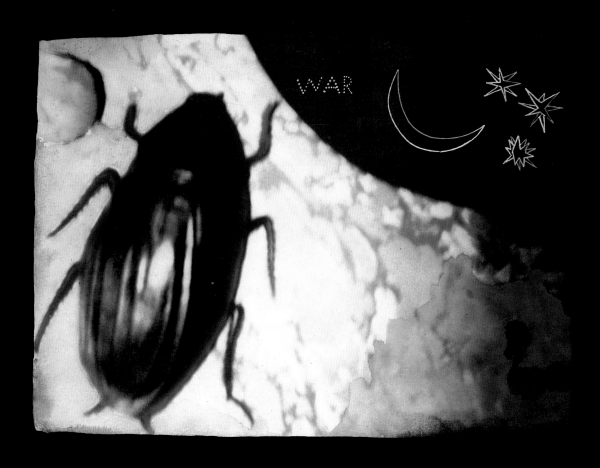

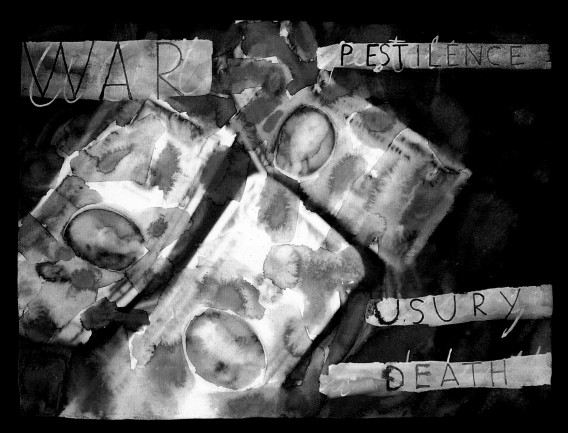

Top: Francesco Clemente, *Island of Time*, from the series "War, Pestilence, Usury, Death," 1992
Bottom: Francesco Clemente, *Ancient Manuscript*, from the series "War, Pestilence, Usury, Death," 1992

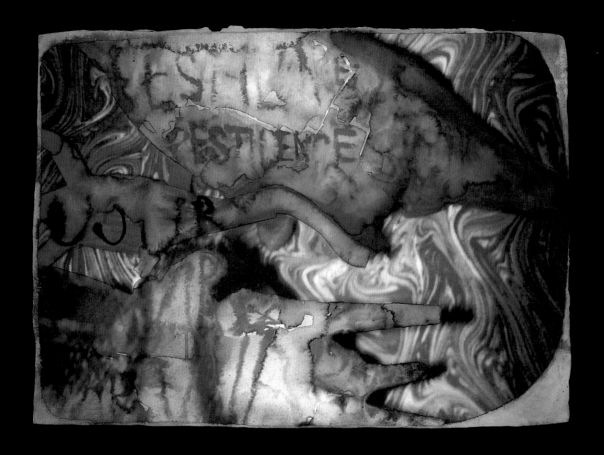

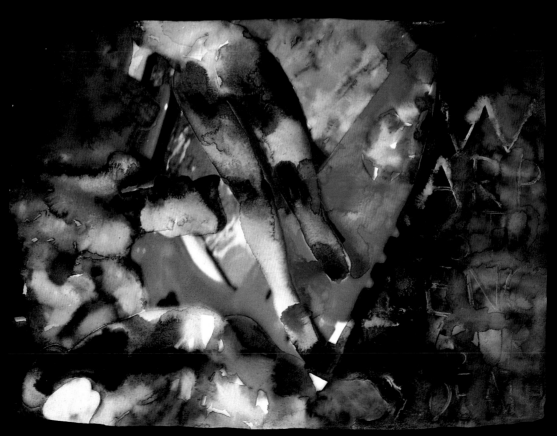

Top: Francesco Clemente, *Sky of War*, from the series "War, Pestilence, Usury, Death," 1992

Bottom: Francesco Clemente, *Ocean Floor*, from the series "War, Pestilence, Usury, Death," 1992

DRAWING FROM THE IMAGINATION

THE COMIC ART OF DARIO FO

BY RON JENKINS

> Fo uses laughter to turn the world upside down, to give power to the powerless, and to ridicule the sacred cows of authority. The absurd reversals in Fo's comic theater are echoed in the fanciful ironies of his paintings. . . .

"The clown has taken the place of the Pope," laughs Dario Fo as he surveys the exhibition of his artwork in a deconsecrated fifteenth-century church. He strolls gleefully around a Harlequin that sits on a throne in the center of the church beneath an effigy of the Pope that hangs suspended from the ceiling in an undignified pose. On first glance, one might imagine that the Pope is ascending toward heaven, but a closer inspection reveals another joke: the flying Pope is wearing Fo's face, a memento of the 1991 satirical play in which Fo played the part of a pontiff embroiled in drug dealing and corruption. The real Pope has been thrown out of the church completely and banished to hell in a satiric monologue being performed later that evening by Fo's wife, Franca Rame. Written by Fo, the monologue recounts a Dantesque voyage to the underworld, where Rame finds the head of the Vatican consorting with crooked politicians while starving children ask for food. Shocked to find the Holy Father in hell, Rame is informed reassuringly by the devils that he's only visiting.

Fo uses laughter to turn the world upside down, to give power to the powerless, and to ridicule the sacred cows of authority. The absurd reversals in Fo's comic theater are echoed in the fanciful ironies of his paintings, sketches, and scenic designs. His visual and verbal skills conspire to construct a delightfully subversive vision of Italian politics, culture, and religion. The sixty-seven-year-old Italian master began his career as a student of painting and architecture, but went on to gain international acclaim as a comic actor, satirist, and playwright. Dozens of his plays have been translated into over thirty languages and he is now Italy's most frequently produced living playwright. While he is recognized primarily as a performer and writer, Fo's drawings and watercolors reveal the visual foundations of his comic art. The play of color, composition, and perspective in his artwork mirrors the tricks of character, narrative, and point of view he uses to seduce his audiences from the stage.

Fo attributes his story-telling techniques to the medieval Italian troubadors known as *giullari*, these comic minstrels traveled from one town piazza to another performing Bible stories and historical chronicles. Fo's intimate and irreverent style helped to humanize the gospels for audiences of peasants whose lives were distant from the formalities of the Roman Catholic Church. Fo believes that these popularized unofficial versions of Bible lore were influenced by medieval folk paintings of religious subjects, and that the painters were in turn influenced by folk processions of religious mystery plays. He has studied all these arts in an effort to re-create the effects achieved by the *giullari*. It is, in a way, the theatrical equivalent of cinematic montage.

"When painters tell a story, they are outside language," explains Fo. "They don't show the perspective of only one person. They show diverse points of view. In the sacred presentations of the mystery plays in the Middle Ages, people would play a variety of scenes from the life of Christ, showing the actions of Jesus, the Madonna, the devils, etcetera. And when the painters designed their religious frescoes, they mechanically re-created the things that they had seen in the theater of the religious festivals. The painters show the processions as they are seen from different points of view: the same scene from behind, from the front, from a distance. The techniques of cinema were not born with the invention of the camera. They have been used by painters and storytellers for hundreds of years."

Fo's first solo masterpiece on the stage made direct reference to his medieval predecessors. Entitled *Mistero Buffo* (Comic mystery play), the 1968 stage piece is an epic representation of the gospels, in which one man plays all the parts. When Fo recounts the resurrection of Lazarus, for example, he demystifies the event by presenting it from the viewpoint of the masses. Jesus becomes a peripheral character as Fo shows the reactions of the peasants and working people who have come to the graveyard to watch the miracle. Working solo, he becomes the characters in the surging crowd: the sardine vendor hawking refreshments, the worm-infested corpse, and the gamblers taking odds on the miracle's chances of success. When it was broadcast on Italian national television in 1977, *Mistero Buffo* was declared blasphemous by the Vatican and Fo was banned from state television for the next eight years.

Mistero Buffo employs the shifting points of view Fo discovered in medieval frescoes, but the relationship between Fo's paintings and performances can be seen most clearly in his newest epic, *Johan Padan and the Discovery of the Americas*. Padan is an imaginary character inspired by Fo's readings of fifteenth- and sixteenth-century diaries written by European explorers of the New World. As he began imagining Padan's adventures as a con man, shaman, and New World/*giullare*, Fo outlined his story in pictures rather than words.

"These drawings are not illustrations of the story," emphasizes Fo. "They are the story as it existed before it had ever been told." The sketches are a visual record of Fo's imagination as his story was taking shape in words and movement. As he speaks about the pictures, Fo's supple body mimics the curves he has painted on the page. "One sketch shows the Indians dancing for joy," says Fo. "It looks like lots of different people dancing, but I become each one of them when I act out the scene onstage." Fo dances all the shapes in the collective celebration by himself, a one-man bacchanalia whose rubbery limbs display the same freedom expressed in the willowy forms of his painting.

Watching Fo perform the story in the theater, the audience is struck by its unique pictorial style. Alone on the stage, without props or costumes, Fo creates a panoramic landscape of shipwrecks, warfare, feasting, treachery, and magic. When the Italian sailor Padan teaches the Native Americans to frighten the Spanish conquistadores with fireworks, Fo paints the illusion of a pyrotechnic display in the sky with nothing but the explosive sounds of his voice and the quicksilver motion of his hands. The black space above his head becomes his canvas, and Fo's fingers trace the swirling jets of light. A few minutes later he

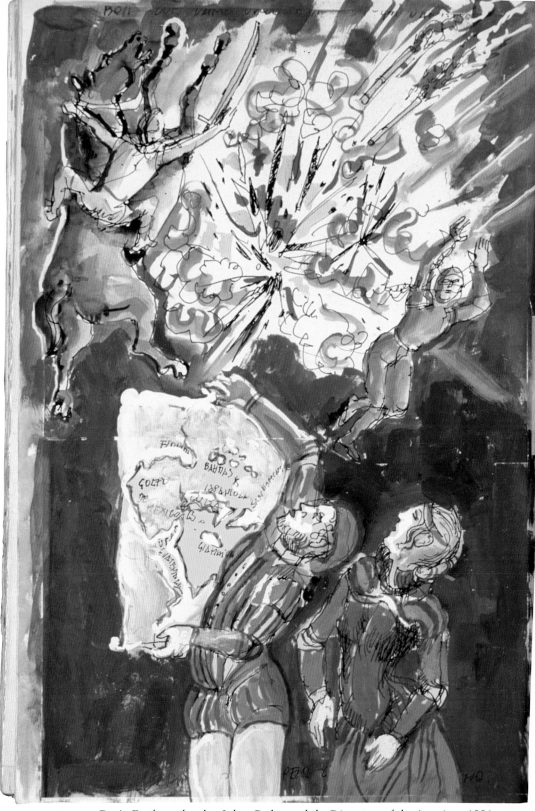

Dario Fo, from the play *Johan Padan and the Discovery of the Americas*, 1991

tells of the smoke signals used by the Indians to communicate across long distances. His gestures conjure up the fire, the clouds of smoke, and the Indians' message of despair as they signal for rescue from the European invaders.

The fireworks and smoke signals that Fo conveys so vividly onstage have their origins in the drawings he made as he was piecing together the story. The sketches capture Padan's adventures as Fo first conceived them in a visualized stream of consciousness. They depict the carnage wrought by the Spanish, the comic miracles performed by Padan, and the lush landscape of a pre-Christian America. Fo's drawings are the fireworks of his creative process and the smoke signals of his imagination. They explode onto paper with cascading bursts of color, and float contentedly on the page. Images rise up out of one shape and dissolve into the next. For those who have seen Fo create these illusions on the stage, the sketches are startling reminders of his mercurial style of acting. For those who have never seen him perform, they offer a tantalizing glimpse into the mind of a clown.

THE GOSPELS ACCORDING TO FO

BY DARIO FO

The following narrative is excerpted from a monologue written and performed by Dario Fo, Johan Padan and the Discovery of the Americas. *Fo improvised and refined the text as he played it nightly from the fall of 1991 to the spring of 1993. He acts all the parts himself, suggesting character changes with slight shifts of tone and creating scenic effects with gestural montage and onomatopoeic sounds. The narrator is a shipwrecked Italian sailor named Johan Padan who flees persecution from the Spanish Inquisition and finds himself in the New World at the end of the fifteenth century. His skills as a fireworks expert and confidence man lead to his being accepted by the Native American Indians as a shaman. Padan uses his influence with the Indians to teach them a variety of methods for resisting the Spanish conquistadores. In this scene, Padan tries to help the Indians to use Christianity as a subversive means of self-defense, but he has difficulty explaining the logic of the faith that the white men use to justify their plundering of America. Padan is speaking directly to his theater audience, recounting his adventure. As this section of the narrative begins, Padan is quoting himself as he spoke to the Indians. —R. J.*

Listen, good people. Soon we'll be meeting the Christians, and there's only one way to stop them from murdering and enslaving you. We have to take away the pretext they've invented to justify themselves. They say you're not men of Christ, but savages, with no religion, no soul, no spirit, no God. And so to be saved you've got to become their Christian brothers. You've got to be taught the Christian doctrines. But since there aren't any priests here to teach you, I'm afraid you'll have to learn the Gospels from me [laughs], a blasphemer, anti-Christ [laughs]. You'll just have to take my word for it.

Gather around. Silence. Sit down. Everyone. We'll start the lesson now. And you better pay attention, because later there will be a quiz.

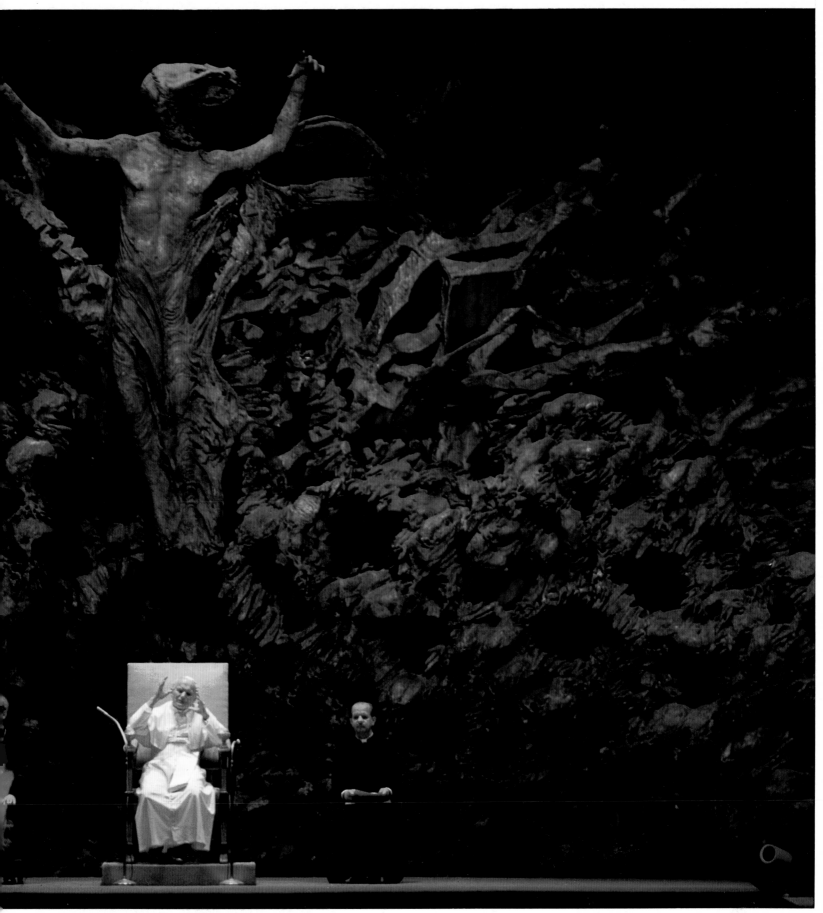

Piero Guerrini, *Pope John Paul II*, Rome, 1987

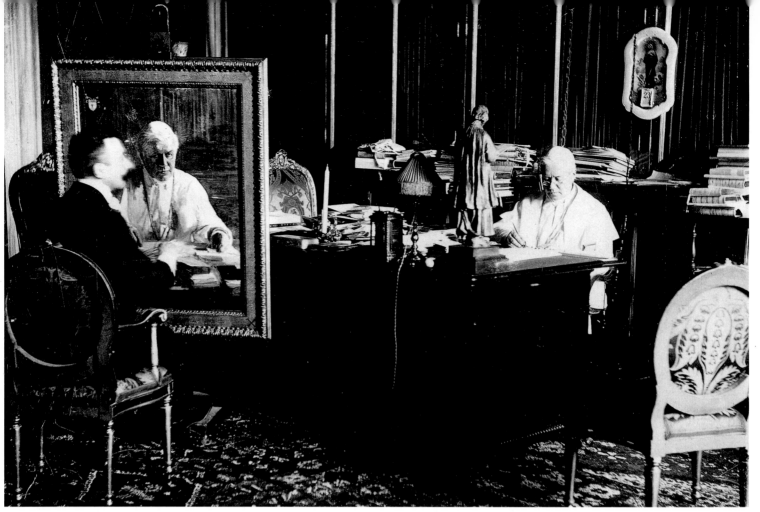

Pius X having his portrait painted, ca. 1910

Signing of an agreement between the Holy See and the Italian government, February 1929
From left to right: Francesco Borgognini Duca, il Cardinale Gasparri, Benito Mussolini, Dino Grandi

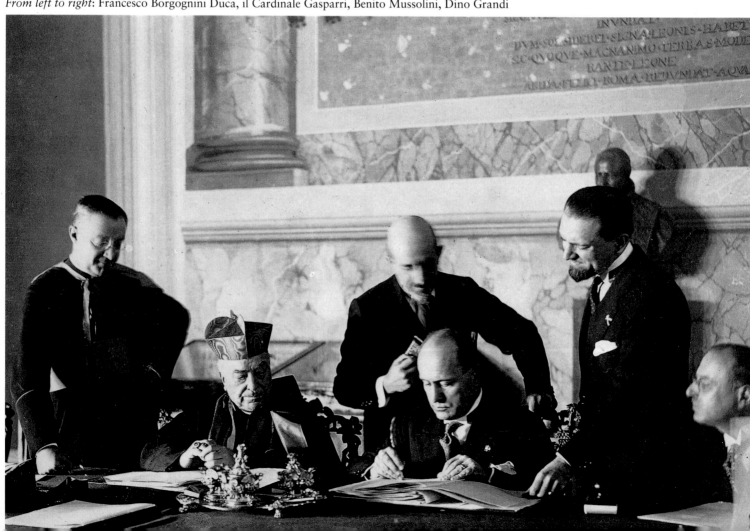

First rule. Christians have a soul. Good souls go to heaven, for eternity. The body stays in the ground, eaten by worms, but the soul is eaten by no one, because it goes happily to paradise and leaves the body behind. If you are cruel, you go to the fires of hell, and burn for eternity. How do you like that? You don't like it? You don't understand? That's okay. You'll understand later.

The hardest thing to explain to them was the part about God.

The Christians have only one God. One, but also three. The Trinity. Three in one. But sometimes two. Father and Son. Then again, only one. But if you want, maybe three. Or maybe two. No, just one. How 'bout two. Only one. How 'bout three. Maybe two. Whaddya want. Gimme three. No just two. A one and a two and a three and a one [he gets carried away, like a mad conductor warming up the band, singing out the numbers in a nonsensical rhythmic rhyme]. I don't understand it myself.

It was also difficult to get them to understand the part about original sin.

In the beginning there was Adam and Eve, two people who lived in the woods like you. An innocent couple who never wore clothes and loved each other serenely with nothing to be ashamed of. Then a big sneaky snake came along with an apple in its mouth and said,

"Adam, eat the apple."

"No, I'm not interested in apples."

"Eat the apple and it will make you the equal of God."

"I'm not interested. I don't like apples."

So he goes to Eve.

"Eve, eat the apple."

"Okay, and I'll save half for Adam. Some for you, some for me."

Then out jumps the angel Gabriel, or maybe it was Michael. I don't remember his name, but he had a sword in his hand and shouted,

"Wretched woman, you ate the forbidden apple. Get out of paradise."

The Indians jumped up right away and said,

"That one must have been a Spaniard."

It was tough to make them understand the story of the apple, because they didn't know what apples were. So I had to say that the sneaky snake had a mango in its mouth. A mango big as a watermelon, and the poor snake had to stretch its mouth so wide that it could barely talk,

"Aaaadaaaam, eeeeat da manggggghooooo."

"Eh?"

"Da maanngghamanghamaaaannngggghooooo."

He had to point with his tail.

"Da manngghooo."

And it was also pretty hard to get them to understand about being ashamed of sin.

At first they're happy to walk naked in the woods without a care in the world. Then all of a sudden they're ashamed of their pubic hair. The angel Raphael starts screaming about the forbidden apple, and before you know it they're hiding their crotches.

"Oh, how embarrassing! Please don't look at my butterfly!"

It just didn't make any sense to them. Especially the part about covering your privates with fig leaves. The Indians didn't have fig trees. They had cactus.

"Owwwch!"

But when I told them about Jesus, Son of God, with his long hair, so young and full of smiles, oh how they liked it. They loved to hear about him meeting cripples who danced away shouting,

"Thanks for the miracle, Jesus."

The only thing they didn't like about Jesus was the twelve apostles who followed him around with halos on their heads. The Indians couldn't understand why they were all men. Only men. It made them suspicious.

Since they wanted to hear about women, I decided to make them happy and tell the story of Mary Magdalene. Oh how they loved Mary Magdalene, with her beautiful thighs and full breasts covered only by her long dark hair. [He pantomimes her lustfully revealing her body and breaks out into shouts of ecstasy.]

I told them how she and Jesus would lie together in the sun swinging on a hammock, and the Indians asked,

"Did they make love?"

No, I don't think so. It's not written in the Gospels.

"What does it matter whether it was written or not? Of course they made love. A gorgeous girl like that, so passionate, lying there in the arms of the Son of God, God himself, right there next to her. A beautiful woman. A sensitive man. And you think Jesus didn't make love with her. The Son of God. For God's sake, they must have made love!"

No one knows. It wasn't written in the Gospels.

"It was written. Someone must have torn out the page."

On the other hand, they weren't too crazy about Jesus'
old man. No, they didn't much like the Heavenly Father.
Not after they heard the story about Isaac and Abraham. I
told 'em how old Abe had a sweet tender little baby that he
loved to play with.

"*Come here little Isaac, come here.*"

"*Oh daddy, oh daddy.*"

"*Izzy, Izzy, cute little Izzy.*"

"*Hug me. Hug me.*"

While they were playing, God got jealous and cried out
from Heaven,

"Bravo. Now that you've got your cute little boy, you
forget all about me. You don't say your prayers anymore,
or make me offerings like you used to."

"*Yes, you're right. Tell me what I can do to make it up*
to you. What sacrifice can I make for you?"

"Well, if you really love me, bundle up your baby, carry
him to the top of the mountain, build a big fire, stick your
baby's head in it, and cook it up for me so I can smell the
aroma of fresh broiled baby. It's my favorite. Mmmm!"

"*My Lord. It's horrible, what you're asking. Wouldn't it*
be better if I burned four baby goats and…"

"No! I only want one. Your baby."

"*Maybe I could give you Thomas instead. He's a little*
bigger."

"No! I want the smallest one. And if you don't give it to
me I'll have a fit and send another flood."

"*No, don't get angry. Oh Heavenly Father, what a*
horrible thing you're asking. I would rather rip off my
own skin and eat it raw on my knees before you, God. But
if you ask me for this sacrifice, I will do it for the love of
my Lord. Turn around, Isaac. Don't look at me."

He lifts a huge knife into the air over his son's head.

"*It's for you that I make this offering, my God! God!*"

Then an angel came.

"STOP!"

And God came out from behind the clouds,

"Ha ha ha ha ha ha. Bravo, you fool. I was only kid-
ding. Ha. Ha ha ha ha!"

They didn't like him. They didn't like him. But when I
told the Indians about the Passion of Jesus, nailed to the
cross, with his mother the Madonna tearing her hair out
beneath him, and Mary Magdalene there too crying her
eyes out and all the saints weeping, the Indians started
crying too.

"*Poor boy. Poor boy,*" *they moaned, pulling out*
their hair and weeping as if it were their own dearest

child who was about to die. They were rolling on the
ground in grief.

Enough! That's enough! Now you're going too far. It's
true that he died. But after three days he came back to life.

"What?"

Jesus is coming back to the world.

"Really, the Son of God's coming back?"

Yes.

"No, you just made that up to console us because we're
so sad and desperate."

No. Careful now. There was another one with doubts
like yours, Saint Thomas. He didn't believe it either and
went down to Jesus' tomb to see if he was really alive. But
when he reached out to touch the sores on Christ's naked
body a thunderbolt came down from heaven. Thwack.
Swizzle. Scorched fingers. Then he believed.

"So it's true. It's true. Jesus didn't die. He's alive! He's
alive!"

They fell down on the ground with joy. They started
making love, right there in front of everybody. They
rolled around. They drank. They danced. And then to
cap off the celebration they gave everyone hollow reeds
and a white powder they called Borax. In their language
Borax was the word for intoxication. They put a little
powder in the reeds, stuck them up each other's nostrils
and blew.

Prruf! Ahhhh!

"Me too."

Prruff! Ahhh! [in ecstasy]

"I can see **God**."

Stop that! What are you doing? Snorting drugs? Danc-
ing? Making love? In front of God? Getting drunk?

"Why? Isn't it right?"

No!

"You're not allowed to dance in front of God?"

No!

"Or drink?"

Only the priests drink. Everybody else just watches.

"You're not allowed to make love?"

No!

"Or sniff a reed?"

No!

"Not even a little one?"

No!

"Aaaoooh! What kind of dead religion is that?"

Translated from the Italian by Ron Jenkins

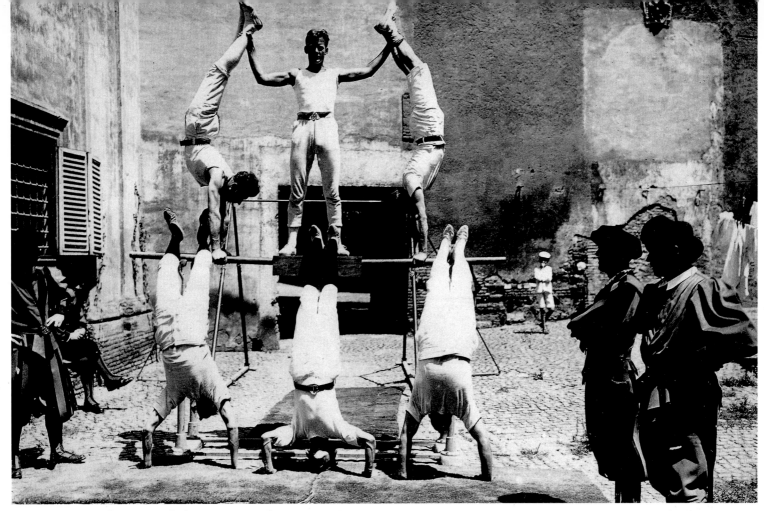

Swiss gymnasts in the courtyard of San Damasco, the Vatican, 1926

Pius XI and Guglielmo Marconi experimenting with
shortwaves in the Vatican gardens, 26 April 1932

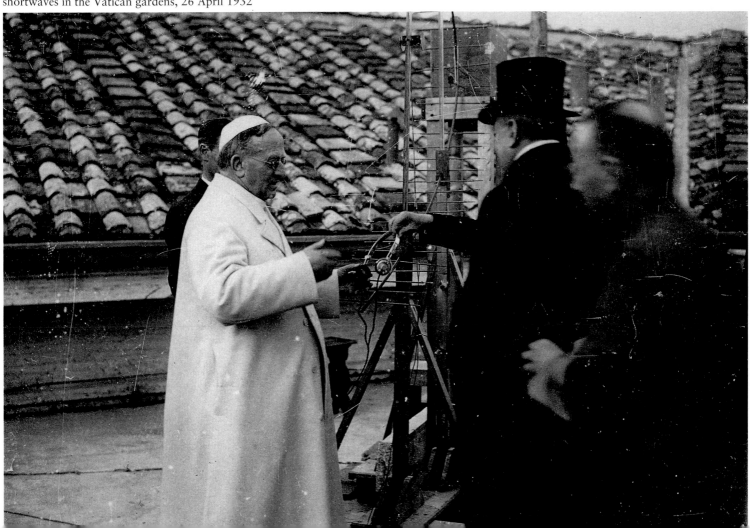

FLASH WARNING

THE PAPARAZZI ARE COMING

BY MASSIMO DI FORTI

> The paparazzi,
> those fastidious Italian
> scoop-hunters, were
> anything but star-struck
> and had no respect
> whatsoever for myths. They
> resorted to every possible
> trick or expedient necessary
> to achieve their ends.

First came the flash. And the flash was a weapon. It served to capture the fleeting moment, breaking with the tradition of the posed image, and helping to usher in the era of aggressive photojournalism.

The paparazzi went around—cameras ready, flash always on—like a bunch of policemen with guns drawn, in pursuit of their prey, waiting for something interesting to happen, for the right person to pass by. What was new was the nature of the prey: Hollywood figures, crowned heads of state, famous artists, all wandering bewildered amid the anonymous crowd, which wanted to be able to scrutinize close-up—even for just a moment—the beautiful people, the rich and famous. Anna Magnani, Tennessee Williams, Coco Chanel, Orson Welles, Audrey Hepburn, Louis Armstrong, Jean Cocteau, Liz Taylor, Gary Cooper, Linda Christian, and Tyrone Power—all the stars and would-be stars of the period—paraded among the tables of the bars along Rome's Via Veneto. But the paparazzi transformed those runways into pandemonium, and scandal always lay in ambush.

What a weapon, the flash! The paparazzi used it with cynicism, impudence, merciless skill, just as—a decade earlier—the great Weegee had done. And they often adopted an outright warlike strategy, working in groups to trap their unsuspecting prey between "two lines of fire." Rarely did the celebrities slip through their nets.

For movie stars, accustomed as they were to being photographed in studios and having complete control over their image, this treatment was an incredible, invasive shock. The paparazzi, those fastidious Italian scoop-hunters, were anything but star-struck and had no respect whatsoever for myths. They resorted to every possible trick or expedient necessary to achieve their ends. Velio Cioni (who, together with Tazio Secchiaroli and Sergio Spinelli, founded Roma's Press Photo agency in the 1950s) used the device of a tiny camera hidden in a book with a hole in the cover, made specifically to leave the lens free for shooting pictures unbeknownst to the subject.

With the passage of time, the new image-predators resorted to means that, while perhaps less ingenious, were even more powerful and sophisticated. The telephoto lens is one example, a device that was developed as a kind of weapon. As the famous portraitist and essayist Gisele Freund notes in *Photography and Society:* "The paparazzi use telephoto lenses to capture people in their private lives. Telephoto lenses, which allow one to approach subjects that you want to photograph from a distance, were perfected during the last war, for spying upon the enemy. The German forces used them to film the coasts of England." That was the end of privacy.

The paparazzi were poor. Some, like Secchiaroli, initially made a living photographing tourists. They got by any way they could, all the while observing Rome—which was crawling with celebrities—with the curiosity and festering jealousy of one who feels excluded from a party. Finally, they decided to act. They did so in the only way possible for these marginalized descendants of Machiavelli, who professionally speaking were nobodies, and who wouldn't have had the slightest chance of being taken on by the large photography agencies or magazines. Not respecting the rules of the game, they invented a new way of working that involved trickery, subterfuge, and small, photographic "thefts"—"stolen" images. In the span of just a few years, Secchiaroli went from being an obscure, itinerant photographer of tourists to being a sort of hero, an international celebrity, dubbed the "human-photo-machine-gun" by the American press.

Illuminated by the burst of the flash, from scandal to scandal, *la dolce vita* was born. The attack-photographers' ritual of the celebrity-hunt reached its culmination during the 1958 evening of Ferragosto (August 15, the traditional start of the summer holiday in Italy), in a practically deserted Rome. Secchiaroli and three of his colleagues— Pierluigi, Uberto Guidotti, and Giancarlo Bonora— arrived on their Vespas on the Via Veneto, where Farouk, former

Franco Pinna, *Tazio Secchiaroli on a Vespa*, ca. 1959

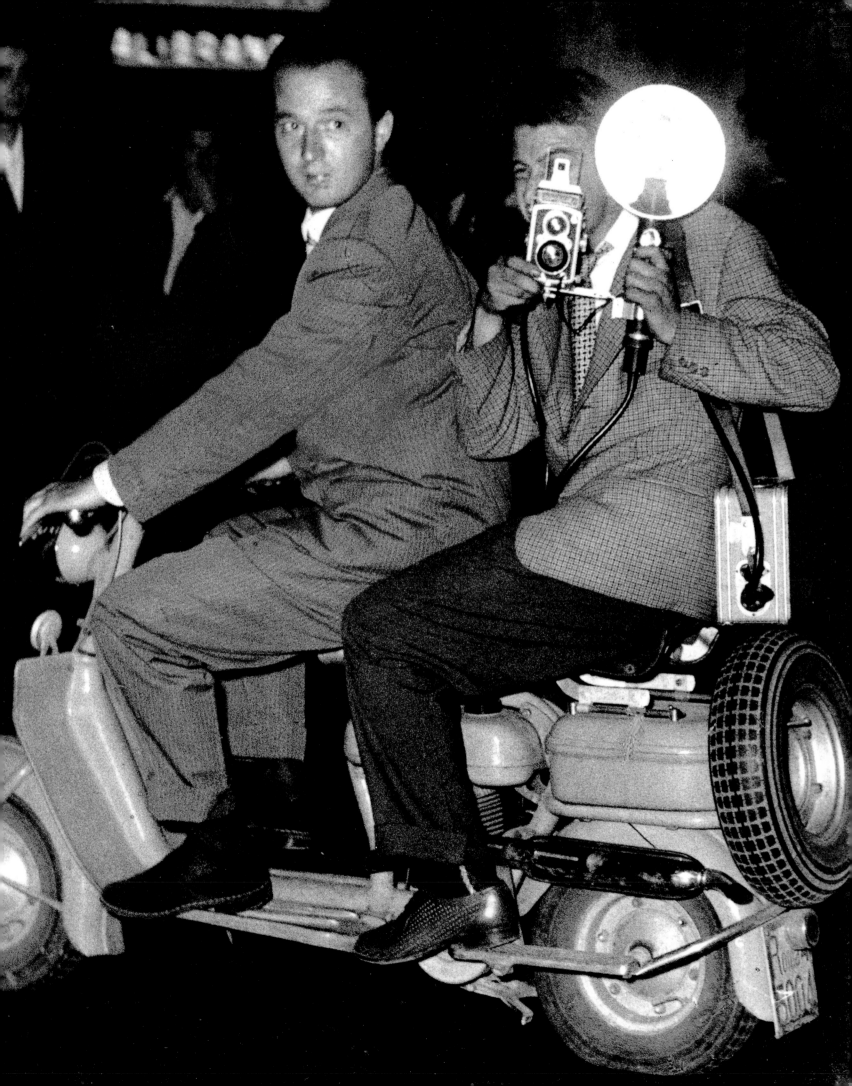

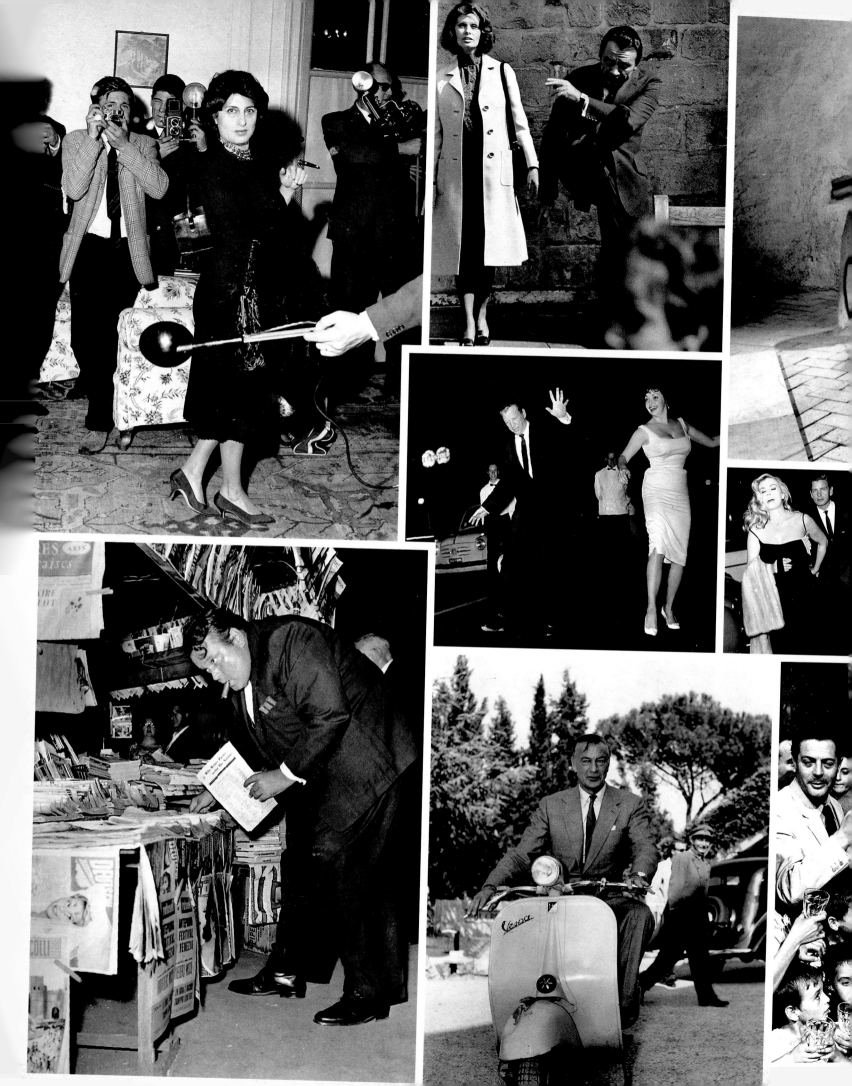

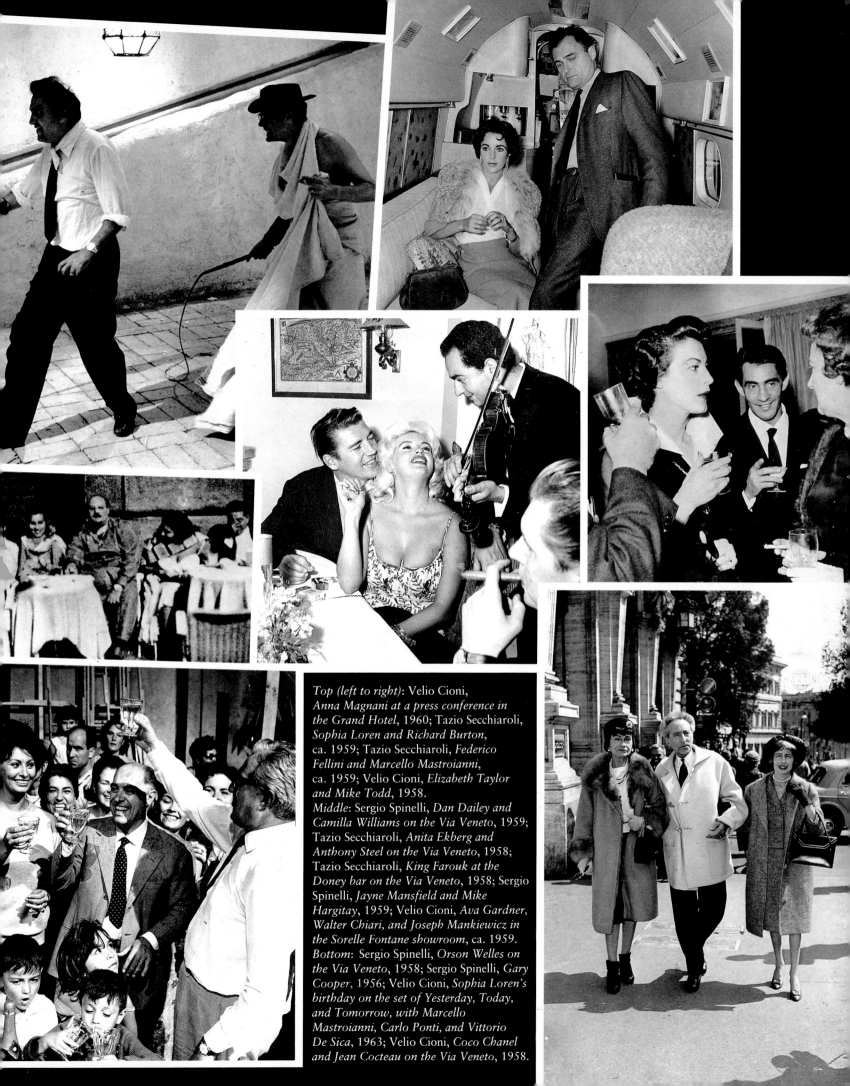

Top (left to right): Velio Cioni, Anna Magnani at a press conference in the Grand Hotel, 1960; Tazio Secchiaroli, Sophia Loren and Richard Burton, ca. 1959; Tazio Secchiaroli, Federico Fellini and Marcello Mastroianni, ca. 1959; Velio Cioni, Elizabeth Taylor and Mike Todd, 1958.

Middle: Sergio Spinelli, Dan Dailey and Camilla Williams on the Via Veneto, 1959; Tazio Secchiaroli, Anita Ekberg and Anthony Steel on the Via Veneto, 1958; Tazio Secchiaroli, King Farouk at the Doney bar on the Via Veneto, 1958; Sergio Spinelli, Jayne Mansfield and Mike Hargitay, 1959; Velio Cioni, Ava Gardner, Walter Chiari, and Joseph Mankiewicz in the Sorelle Fontane showroom, ca. 1959.

Bottom: Sergio Spinelli, Orson Welles on the Via Veneto, 1958; Sergio Spinelli, Gary Cooper, 1956; Velio Cioni, Sophia Loren's birthday on the set of Yesterday, Today, and Tomorrow, with Marcello Mastroianni, Carlo Ponti, and Vittorio De Sica, 1963; Velio Cioni, Coco Chanel and Jean Cocteau on the Via Veneto, 1958.

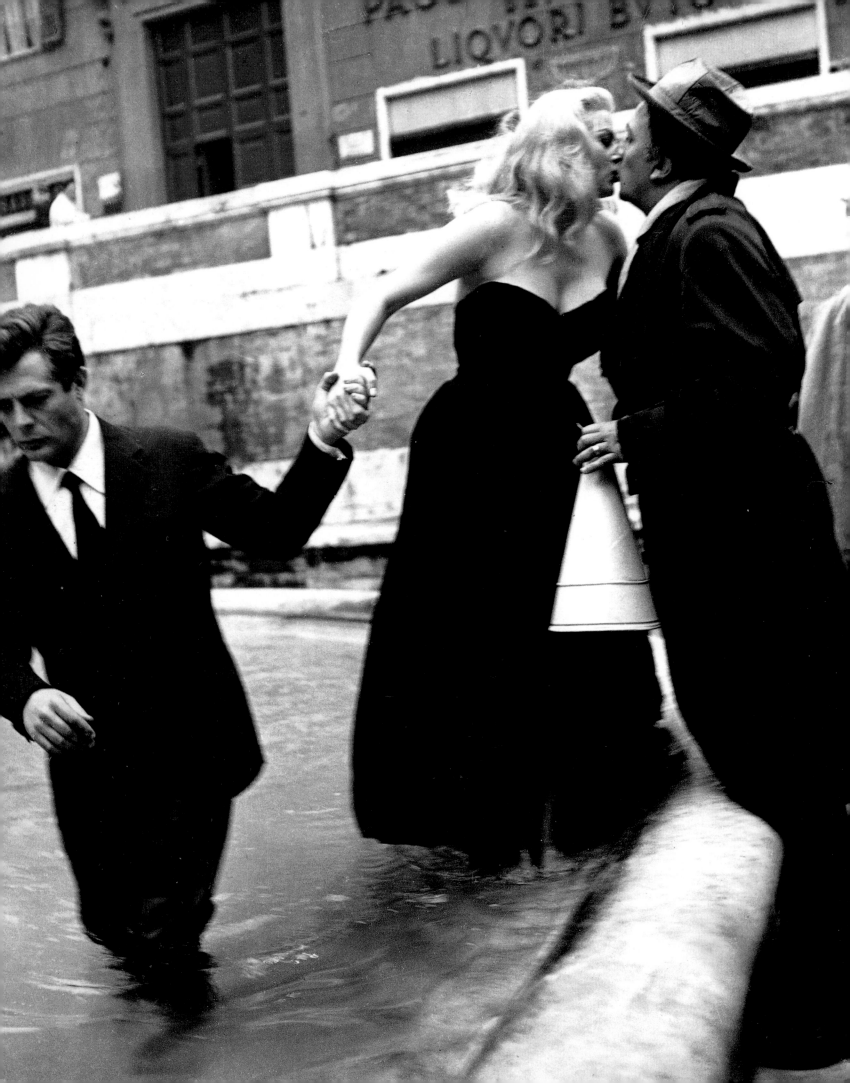

king of Egypt, was sitting at the Caffé Doney with his sister and the singer Irma Capece Minutolo. It was Secchiaroli who unleashed bedlam, perhaps to outdo his friends and to be able to boast of his own exploits. Without warning, he leaped in front of Farouk. The monarch, alarmed that he was being attacked, seized the photographer by the neck. Tables and glasses went flying, in a free-for-all that was like something out of a 1950s Western. And the evening was just beginning. A half hour later, in a nearby spot, a violent brawl broke out between Ava Gardner and Anthony Franciosa. And shortly afterward, the paparazzi immortalized Anita Ekberg and her husband Anthony Steel making their way, dead drunk, through the city streets. All this was enough to strike the fancy of the mass media. The weekly magazine *L'Espresso* came out with an eloquent title: "Cacciatori di teste a colpi d'obiettivo" (Lens-shooting headhunters).

Nineteen fifty-eight was a year of madness. The most famous event? The setting was a party at the Rugantino restaurant in honor of the American millionaire Peter Howard Vanderbilt, and the assembled guests included Anita Ekberg, many representatives of the Roman nobility, playboys on the make—and a small group of paparazzi, led by the ever-present Secchiaroli. As Aiché Nanà began suddenly to strip that evening, they all understood that Roman nights would never be the same.

Scandals. Scoops. The quest for the shocking image became the craze of the times. Proportional debts were incurred as the paparazzi triumphed in ways that, years earlier, had typified the successes of such Italian directors as Roberto Rossellini and Vittorio De Sica, masters of neorealism. This new breed of photographers inaugurated a revolutionary language and broke with convention, despite the extreme poverty of their means—a flash, a Vespa, and a great deal of imagination. And the desire to get to the bottom of things, at any cost. All's fair in war.

The turbulent stars of the time seemed to have been made to order for this craze. In the 1950s, Ava Gardner had become infatuated with the Italian actor Walter Chiari but was still married to Frank Sinatra, and her Roman encounters with her extremely jealous husband were often the occasion for violent quarrels. The manager of the Hotel Excelsior had instructed waiters and all other staff to

think of themselves as soldiers readied for battle whenever the two superstars were guests. Ava and Frank were capable of smashing glass doors and precious crystal, turning their suites upside down or pursuing each other through the halls, transforming the Excelsior into a war zone. For those hunting for scoops, these passions, so tempestuous, were like delicious gifts from above.

On other occasions, lovers' stories had nothing to do with the shots, but the results could be equally substantial. One night, posing for some photos for Pierluigi, Anita Ekberg walked barefoot through the streets in the center of Rome. She hurt her foot near the Trevi Fountain, and lifting up the skirt of her white dress, she

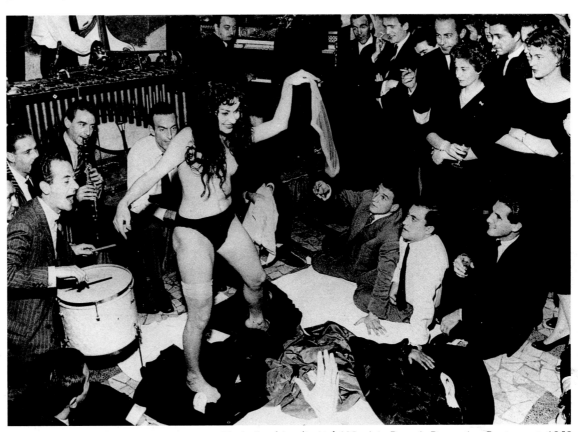

Tazio Secchiaroli, *Aiché Nanà in Rome's Rugantino Restaurant*, 1958

plunged into the water. Pierluigi couldn't believe it. He began to shoot pictures, and sold them later to papers the world over.

Anita's swim in the Trevi Fountain became the most famous scene in Federico Fellini's *La Dolce Vita*. In 1958 Fellini was already celebrated as a director. He had made *La Strada, I Vitelloni, Nights of Cabiria*. Meanwhile, every evening, like clockwork, he paid a visit to the Via Veneto and went looking for the paparazzi, noting the scoops. Two years later, *La Dolce Vita* came out and was a huge international success. But Fellini's masterpiece seemed to mark a turning point of that unrepeatable celebrity-hunting season. The age of the flash and "la dolce vita" soon passed, leaving a trail of star dust in its wake.

Translated from the Italian by Marguerite Shore

Velio Cioni, *Anita Ekberg, Marcello Mastroianni, and Federico Fellini on the set of* La Dolce Vita, 1959

POETICA E POESIA

A READING OF RECENT ITALIAN PHOTOGRAPHY

BY ROBERTA VALTORTA

One characteristic in the development of Italian photography is the absence of continuity; it has undergone a constant rebirth of styles or earlier achievements that have been forgotten. This is due largely to the fragmentary nature of Italian culture, the elusive goal of political unification, and the country's lack of a systematic approach to teaching and exhibiting photography.

Thus, important investigations—such as those of the futurist Bragaglia brothers during the second decade of this century, or Luigi Veronsi's ongoing experimentation since the thirties with abstraction and Bauhaus notions—remain isolated. The postwar period saw Italian photography divided between a neorealist-style reportage and a line of investigation that was still amateurish and tended toward poetic, "lyrical" values. Then two "giants" emerged—Mario Giacomelli and Paolo Monti.

Giacomelli, a narrator of poignant human stories, took Italian photography by storm thirty years ago. In his years as an "amateur" photographer, Giacomelli wedded "truth" to abstract graphic and tonal studies in an inimitable manner to which art informel and expressionist idioms were fundamental.

Monti, a coherent *illuminato,* took the descriptive standards of photography's past to heart, and revived them through the filters of Otto Steinert's Subjektive Fotografie and other modern movements, as well as through his awareness of Italian art from antiquity to the Renaissance and Baroque eras. Monti was a Modern; his photography emphasized the importance of the design process, and he was obsessively attentive to the physical, transient nature of things, and to the necessity of experimenting with visual languages. Monti emancipated Italian photography from amateurism and placed it in communication with the broader artistic culture.

Paolo Gioli, *Mano in stato di confusione* (Hand in a state of confusion), 1988

Giacomelli and Monti dominated the scene in the fifties and sixties, yet they too remain isolated, without true descendants. Meanwhile, the following decade found the Italian photography world ready for new expressive outlets. The seventies were marked by great ideological ferment and attention to economic, social, and cultural values: the birth of a different relationship to power.

By 1962 Umberto Eco had begun his studies in semiotic aesthetics with his book *Opera aperta* (Open work), which refocused debate on the concept of "poetics," and which, thanks to the contributions of communication science, located the work of art within a general theory of signs. It was a turning point: Eco hypothesized that the work of art is defined principally as an "ambiguous and self-reflexive message." Photography also began to be seen as a message; no longer the mimesis of reality, nor deliberately "art," no longer document, it was understood as a more complex totality of signs.

In 1970 Ugo Mulas began his "Verifiche" (Verifications): a series of photographs where the theme was photography itself, its language. In the "Verifiche," which have a "coldness" typical of conceptual work, Mulas analyzes all the different aspects of a photographic code. Some of these are portraits: notable is a double portrait of Davide Mosconi (a very interesting contemporary photographer, whose "trittici" of the eighties recall the conceptualism we find in Mulas's work), showing facial changes in relation to the changes of lens.

Mulas came from the world of reportage. In 1967 he produced a book, *New York arte e persone* (New York art and people), after spending time in New York and becoming familiar with the work of artists such as Andy Warhol, Robert Rauschenberg, Marcel

continued on page 34

Luigi Veronesi, *Untitled*, 1978

Paolo Gioli, *Volto animato dal suo doppio* (Face brought to life by its double), 1990

Natale Zoppis, from the series "Museo della memoria: reliquiario" (Museum of memory: reliquary), 1992

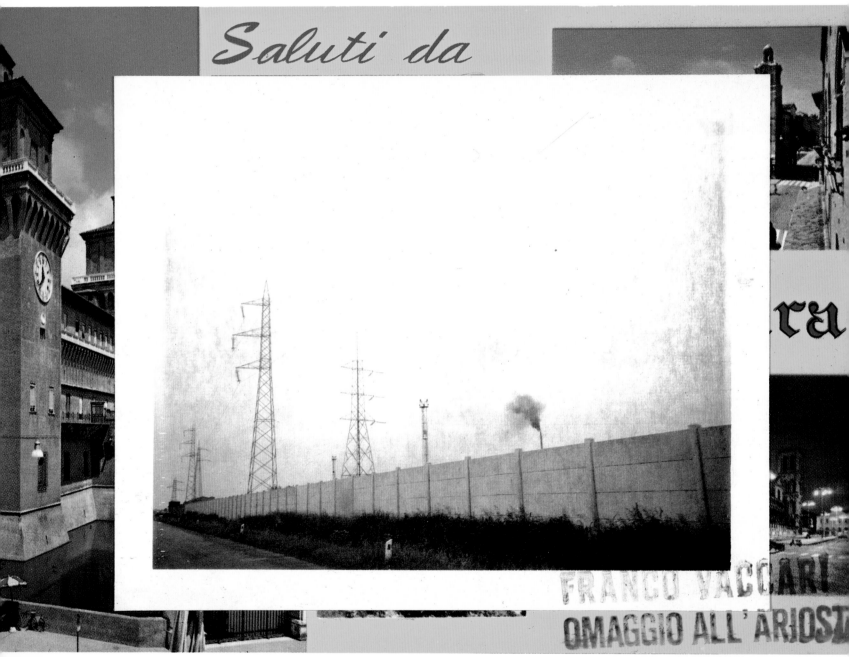

Franco Vaccari, *Esposizione in tempo reale no. 8: Omaggio all'Ariosto*
(Exhibition in real time no. 8: Homage to Ariosto; detail), 1974

"I was invited to participate in the show 'Homage to Ariosto,' to
celebrate the 500th anniversary of that poet. As an 'homage' I took the
same road, from Carpi to Ferrara, that, it is said, Ariosto took one day,
absentmindedly wearing only slippers because it hadn't occurred to him
that he would be walking. During the trip I took Polaroid photographs
and attached them to postcards of the countryside I was passing through,
which I then mailed one by one to the show." —F. V.

Paolo Gioli, *Veduta maledetta* (Evil scene), 1986

Above: Antonio Sferlazzo, *Sunflowers at Dawn*, 1989

Below: Antonio Biasiucci, *Dragoni, Italia*, 1990

Above: George Tatge, *Assisi*, 1989

Below: Martino Marangoni, *Matteo nei campi* (Matteo in the field), 1985

Duchamp, Lee Friedlander, and Robert Frank. Perhaps these associations were what prompted Mulas to experiment with other approaches toward photography, while continuing with his own extraordinary form of portraiture. The "Verifiche" decoded the language of photography, which had until then been conceived according to a "realistic," literal norm. These new works seemed to correspond to the concept of art as message, as expressed by Eco.

Other developments, contemporaneous with Mulas's "Verifiche," indicated the possibility that photography could examine its own methods. One such investigation was Franco Vaccari's famous *Esposizione in tempo reale* (Exhibition in real time) at the 1972

Gabriele Basilico, *Genova*, 1985

Venice Biennale—an experiment in real time, in which an automatic photo-machine was installed and the public was invited to be photographed by it. The public was thus both object and subject, artist and audience. Vaccari struck a new behavioral stance, which invoked a sort of "democratization" of artistic activity, specifically through photography, a medium historically linked to concepts such as reproducibility, instantaneousness, and open social communication.

Other artists were also dealing with the complexity of the photographic code in the same period. Aldo Tagliaferro, for example, belonged, with Bruno Di Bello, to the Mec Art movement. Tagliaferro created a relationship between photographic language and his own ego, and later experimented with the single photo-

graphic image, creating many different pictures from it and hence offering a multitude of perspectives on the same original image.

Between the mid-seventies and the early eighties, even the most advanced Italian photographers could not avoid taking stock of the museums' and art market's attitude toward photography. Some began examining the value of photography on both a cultural and a commercial level, and in terms of work being done in other media.

Paolo Gioli, who began as a painter and later became a photographer and filmmaker, embodies many of these issues in his work. Gioli investigates the historic-linguistic roots of photography, from the camera obscura and the pinhole camera, to conjunctions that photography creates with the graphic arts, to a critical discussion of the technological tool itself. Gioli's constant and concerted effort to place photography and the plastic arts in close relationship, even when the avant-garde seems to have lost its vitality, is historically relevant within the framework of artistic culture in Italy, which is so highly charged with classical tradition. Gioli's approach represents a sort of strategy for the affirmation of photography as an extreme, contemporary outcome of Italian art since the Renaissance. Today, the paths Gioli has pointed out are also being traveled by younger artists, such as Natale Zoppis, who are committed to a new brand of pictorialism.

Similarly, Ugo Mulas's sensibility can be seen in Franco Vimercati's investigations into the relationship between time, memory, and the photographic image, and in Giovanni Ziliani's studies of photographic time. Ziliani works with a clear awareness of the Bragaglias' work— a rare case of consciousness of Italian photography's roots—as well as with a sensitivity to the work of Francis Bacon.

Other paths delineated during the seventies also came to flower during the eighties. Mimmo Jodice, one of the "purest," strongest, and most innovative contemporary Italian photographers, began with conceptual explorations and then moved on to social photography, eventually directing his melancholy and increasingly metaphysical glance toward landscape. Mediterranean light and culture infuse his work, as does a sense of the past. He has developed a style with classical elements, rich with the imagined hues of antiquity, the drama of the Neapolitan baroque and the descriptiveness of eighteenth-century southern landscape. Photographing in Italy's South as well is Mario Cresci, whose work is "open" in a modern way: for him photography is in a realm with graphic design, folk art, and handicraft. His experiments with photographic language began in

continued on page 39

Paolo Giordano, *Interno con lo sconosciuto* (Inside with the stranger), 1983

the seventies, and in the eighties he became interested in the landscape. Antonio Biasiucci's southern focus is, meanwhile, poetically abstract.

Guido Guidi also began his linguistic experiments in the seventies, basing these photographs in a conceptual matrix. Later he moved on to an analysis of marginal sites—anonymous elements of nature and the built world—in rarefied images where the void matters more than the objects that may define it. It is a sensibility both expansive and terse, at times close to Minimal Art, or to *arte povera*. Over the years, Guidi's photographs become inhabited by scattered signs, in a process of growing abstraction. Francesco Radino, whose work maintains a refined quality, is similarly moving toward abstraction, and other noteworthy artists—such as Fulvio Ventura, Vincenzo Castella, Martino Marangoni, George Tatge, and Olivo Barbieri—subject the landscape to an equally compelling, unrelenting and exacting investigation. On the other hand, Roberto Salbitani has chosen to detach himself from the landscape. A narrator, first, of the enigmas of urban solitude, and only second of nature, Salbitani is now considering a territory that encompasses everything: men, places, and animals.

As the art market of the seventies became more active, it increasingly came under critical attack, since the historical moment pushed art toward a communicative function that opposed the concept of commodity. As suggested earlier, the debate over the desired relationship between photography, other arts, the art market, and public institutions became very heated. It was in this context that Luigi Ghirri, a photographer and intellectual, discovered a new synthesis between professional work and artistic exploration, an unprecedented partnership to which contemporary Italian photography owes a great deal. He established a standard for the public as both patron and popularizer of photography.

The world, for Ghirri, was an astonishing mass of scattered signs to be deciphered, a quantity of hieroglyphics. His ironic and fragmented view embraced the landscape of the provinces, the objects and signs that fill our lives. He produced figures and icons, reinvesting the quotidian with an air of the fabulous.

After Ghirri's recent death, his role as mentor for young photographers seems to have been passed on to another landscape photographer, Gabriele Basilico. Basilico's work—monumental and systematic, melancholy in tone just as the end of the industrial era is melancholy—recalls something of Alinari's grand Italian tradition. His work is also rooted in the sensibilities of the great American documentary photographers, from Walker Evans to early Lewis Baltz, as well as in the important European photography from the thirties. Especially influential for Basilico is the Renaissance layout of some of the sites he documents.

Basilico is the great balladeer of this modern world devastated by economic development. His all-encompassing vision, in its beauty and sadness, conceals nothing, leaving us with a sense of the landscape's onetime potential, and its ultimate destiny as we exit the twentieth century.

Translated from the Italian by Marguerite Shore

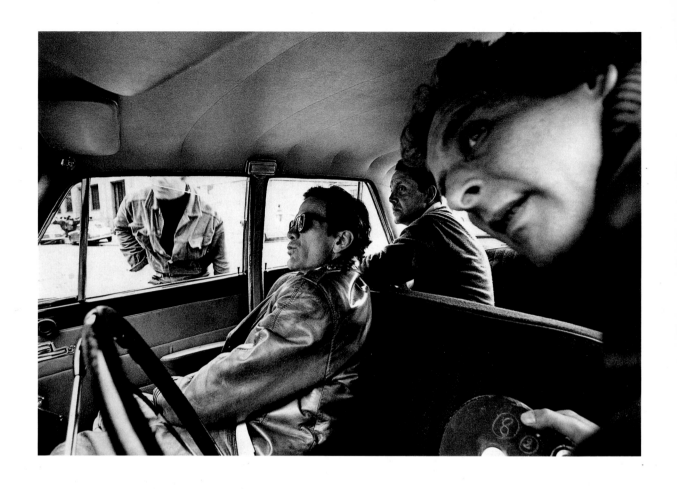

Top:
Ugo Mulas,
*Pier Paolo
Pasolini,*
1966
Bottom:
Ugo Mulas,
Lucio Fontana,
Milan, 1964

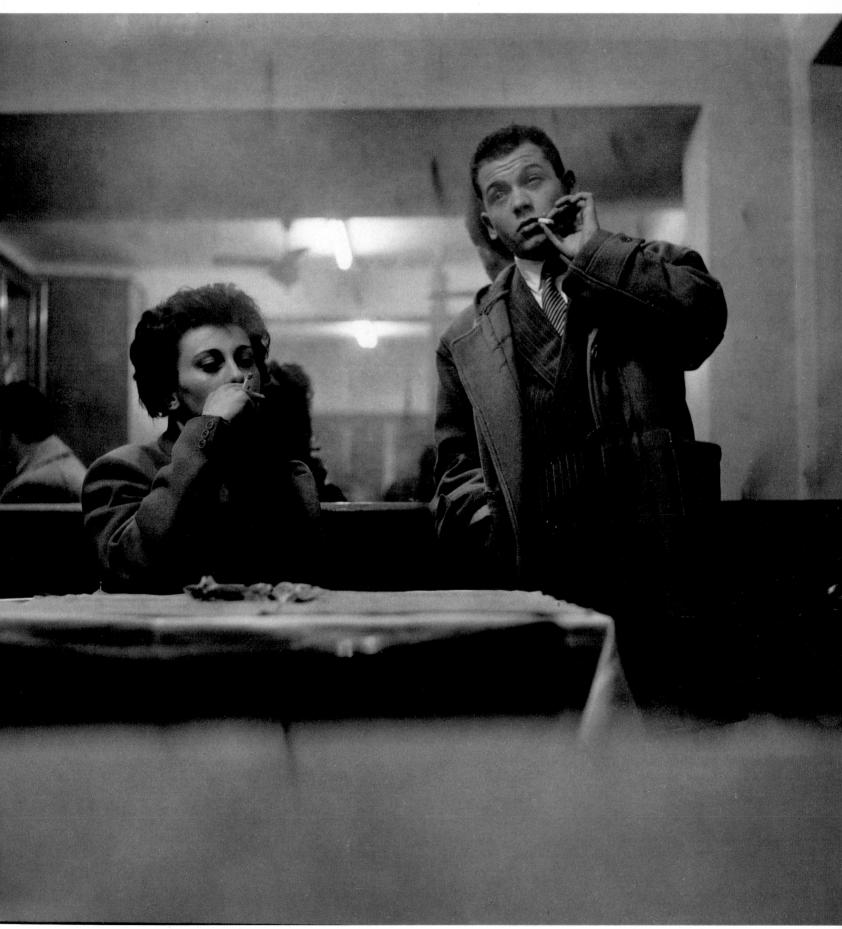

Ugo Mulas, *Bar Giamaica, Piero Manzoni,* Milan 1953–54

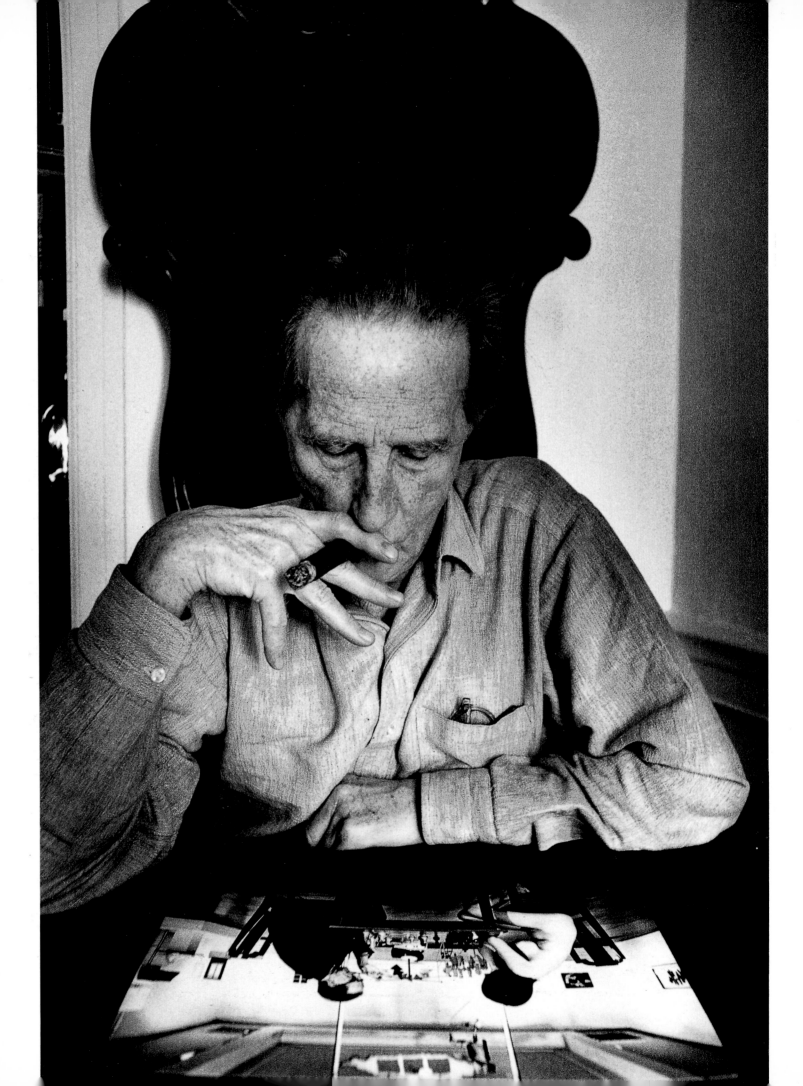

Opposite: Ugo Mulas, *Marcel Duchamp*, New York, 1965

Above: Ugo Mulas, *The End: To Marcel Duchamp*, from the series "Verifiche" (Verifications), 1970-72

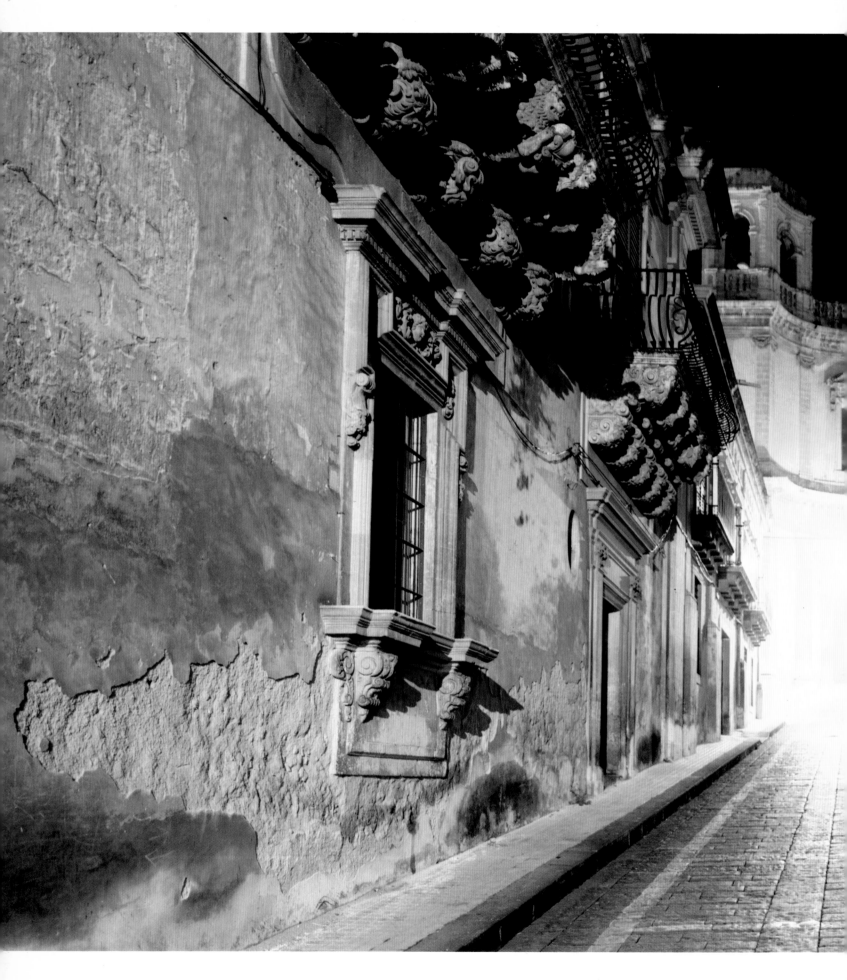

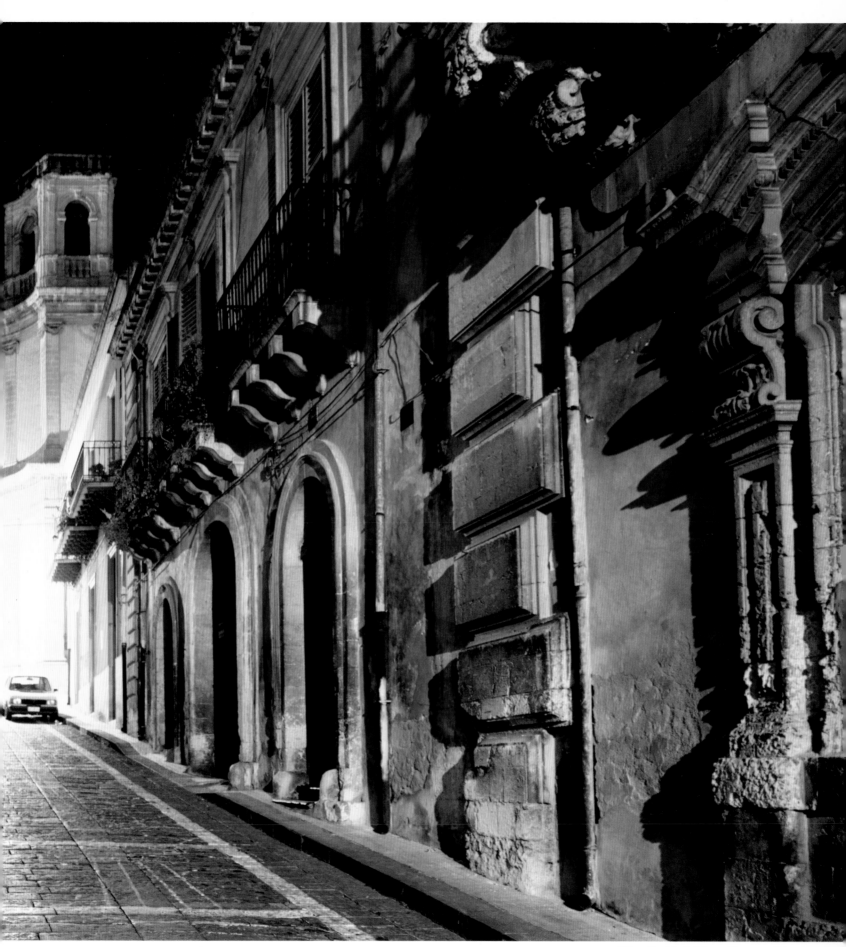

Olivo Barbieri, *Noto, Siracusa* '89

Opposite: Olivo Barbieri, *Roma '87* Luigi Ghirri, *Rimini, Italia in miniatura* (Rimini, Italy in miniature), 1985

Luigi Ghirri, *Parma, interno della certosa* (Parma, inside the charterhouse), 1985

Luigi Ghirri, *Parma*, 1984

A MINIMAL ADVENTURE

BY PAOLO COSTANTINI

> A new generation of photographers embraced Luigi Ghirri's concept of exploration. . . in quest of the "immense, elusive dictionary of the world."

"I don't know if the cultural situation in Italy today is more like a great void or a small chaos," Luigi Malerba wrote some time ago. In this uncertain universe, it seems that we have only a mass of fragmentary observations, animate pages, sequences, projects, and photographs, to show us the many faces of our reality.

For a while now, much Italian photography seems to have ceased attempting to give a comprehensible structure to reality, and instead gazes upon the spaces of our present, accepting all the visual materials that reality offers. This photography seeks to cast the "archaeologist's glance" that Italo Calvino spoke of: a "meticulous and prolonged" attention to even the minimal traces. It is a conjectural exercise in the face of mysterious and fleeting objects. Calvino's methods and intentions as a writer are perhaps closest to those of this sort of photography: "When everything will have found an order and a place in my mind, I will begin to stop finding anything worthy of note, stop seeing what I see. Because to see means to perceive differences, and as soon as differences become uniform in the predictability of everyday life, the glance slips across a smooth surface, without taking hold."

Within the Italian artistic tradition, this photography indicates that not only do objects, people, figures, and ideas exist in space, but space too exists inside things. Photographers explore the voids, the pauses, the distances between objects and formal limits, reiterating the concepts of place and of qualification. Discussing the relationship between narrating and seeing, the writer Daniele Del Giudice recently wrote: "In our completely visible world, what is of great concern to me is the edge where the new invisible is created, that is, mystery."

Some photographers have attempted an arduous exploration of the space of the world, through visible and invisible forms, constructing a geography both real and imaginary, where exterior and interior, view and vision, are mixed and amalgamated. They have focused on the process of seeing and the nature of perception rather than simply describing. The photographers seek, through contemplation, to take command of the multiplicity of possibilities in their subjects, without being overwhelmed. Yet how can one dominate, through a single rapid and summarizing panorama, this discordant collection of forms and signs?

The second half of the 1970s, and the eighties to an even greater extent, saw a new generation of photographers in Italy that embraced Luigi Ghirri's concept of exploration, as opposed to the traditional iconographic conventions for describing the Italian landscape.

These explorations were, in Ghirri's words, in quest of the "immense, elusive dictionary of the world," of the unexpected that can still appear, here and there, "in some unexplored fold of this space"; a "minimal adventure," an investigation into newly formed places. The photographers were convinced of the possibility that the "lure of a mysterious present and of surprise" might surface there. An unanticipated amazement, experienced through small fractures and divergences, desired or determined by events.

The traditional classic itinerary of Goethe's *Italienische Reise* was thus transformed into an entirely new perspective scene, which allowed one to turn back, with "the liberated eye of a man who looks," as Guido Guidi once said, to the classical, worn-out, and unchanging benchmarks of the Grand Tour: objects, moments both recognizable and unknown, inextricably part of everyday life, "seen thousands of times and never observed." Some photographers embarked on that journey, shaping the landscape in new and different ways, shifting from the center out toward the edges, sliding the focal point of vision, constructing unprecedented views, without allowing themselves to be captured by the lures of the seductive *paesaggio*.

Ultimately, a discovery, an emotional relationship with the site delivered the work from banality. Many of the photographs made in the eighties and now in the early nineties seem to be trying to trace a hypothetical moral geography of modern-day Italy. These images remain like small, personal chronicles, sometimes nothing more than pure sensation. But these Italian landscapes have begun to bring to light the infinite and subjective details of a terrain. Although these works may not lead to Goethe's romantic sense of wonder, the all-encompassing "uncertain universe" they depict must still be recognized as our own.

Translated from the Italian by Marguerite Shore

BLOOD TIES: THE MAFIA

BY VINCENZO CONSOLO

Even the etymology of the name is shrouded in mystery: *Mafia*. Where does it come from? What does it mean? In Sicilian and Italian dictionaries the word is sometimes described as deriving from the French, sometimes from the Spanish, sometimes from the Arabic (from *mahefil*, meaning assembly or place of assembly)—etymologies that betray the various foreign dominations of Sicily. Writers, ethnologists, and historians have offered the most disparate explanations of the word's significance. The ethnologist Giuseppe Pitré, author of a monumental work on the customs, practices, and traditions of the Sicilian people, has provided a rather naive and misleading meaning. "The Mafia is neither sect nor association, it has neither regulations nor statutes; the mafioso is neither thief nor bandit. . . . The Mafia is self-awareness, an exaggerated concept of individual power, the unique and sole referee of every conflict, of every collision of interests and ideals; whence comes the intolerance of superiority and—even worse—of any sort of arrogance." In other words, for Pitré, the Mafia character is the manifestation of an individual who has a high concept of self, who is exaggeratedly prideful, who doesn't tolerate impositions of authority, private or public, who quickly rebels against persecution.

Pitré wrote these words in 1889, fifty years after the Attorney General of Trapani, Don Pietro Ulloa, sent the Bourbon minister of justice in Naples a report on the economic and political state of Sicily. "Many regions have *fratellanze* [brotherhoods] . . . without any tie except dependency upon a leader, who might be a landowner in one place, an archpriest in another. A common fund provides for necessities—sometimes the exoneration of an official, sometimes the accusation of an innocent party. The people come to an agreement with the bosses. As thefts occur, mediators appear to offer their services to recover stolen objects. Many well-placed magistrates protect these brotherhoods with an impenetrable cover. It is impossible to convince local citizens to patrol the streets; nor can one find witnesses for crimes committed in broad daylight. . . . In this umbilicus of Sicily, public offices are bought and sold, justice is corrupted, ignorance is encouraged. . . ."

Ulloa's report is the first clear description of the Mafia in its essence: an association of bosses with a capo, a bourgeois landowner or local priest, and underlings. The group's authority replaces that of the state; they corrupt the forces of order and justice, and have these powers provide protection; they subject the populace and force them into a complicit silence, or *omertà*.

After Giuseppe Garibaldi's triumphant campaign in Sicily in 1860, which kindled great hopes for liberation and for social deliverance among the masses in the South, the Bourbon kingdom of the two Sicilies gave way to the unified state ruled by the House of Savoy. At this time the Mafia became even more powerful in Sicily, relying on the greater distance from the central government and on the discontent and mistrust of those in power and of new laws that burdened the masses with new obligations, such as military conscription and onerous taxes. In 1875, only a few years after the unification of Italy, the government sponsored a parliamentary investigation into the social and economic conditions of Sicily, an investigation that, even in its official capacity, in its reticence and in the dearth of information provided by public officials, still gave an alarming picture of the conditions of Sicilian peasants and the excessive power of the Mafia throughout "the Island" (as Sicily was often called).

At the same time, along with the state inquiry, two young liberal scholars, Leopoldo Franchetti and Sidney Sonnino, carried out their own written investigation, which revealed the absolute sequestration of Sicily by the Mafia and the fleeing of the land barons from their vast, untilled estates, to be replaced by the so-called *gabelloti, campieri,* and *picciotti*—Mafia heads and their underlings. Franchetti and Sonnino specifically brought to light the servile conditions, the inhuman exploitation of the peasants and the workers in the sulfur mines, where the *carusi*—children as young as six or seven years old—also labored. Thus the parliamentary inquiry of 1875, Franchetti and Sonnino's investigation of 1876, and Giuseppe Alongi's 1886 essay, "La maffia," together were the beginning of a vast and important body of political journalism on the Mafia, both in Italy and abroad. This investigative writing, now widespread, has reached extremely high levels of discourse, and has offered an explanation for this social phenomenon.

In his 1959 essay, "Primitive Rebels—Studies in Archaic Forms of Social Movement in the 19th and 20th Centuries," the English historian Eric J. Hobsbawn located the origins of the Mafia in the historical-social "backwardness" of the populace, in the survival of a semifeudal society in Sicily. In 1961 Leonardo Sciascia described the Mafia as "an association to commit crimes, with goals of illicit enrichment for the associates, and which is presented as an element of mediation between property and work; one understands that this is parasitical mediation, imposed through violent means." This mediation was perfectly suited to the "historical" Mafia, to the Mafia of the estate holders, where *cosche* and *famiglie* (bands and families), strictly linked to one another, were ruled by a capo, who was known to all, if not officially recognized. This was the Mafia of Don Vito Cascio Ferro, the instigator of the assassination in Palermo of the Italian-American police officer Joe Petrosino in

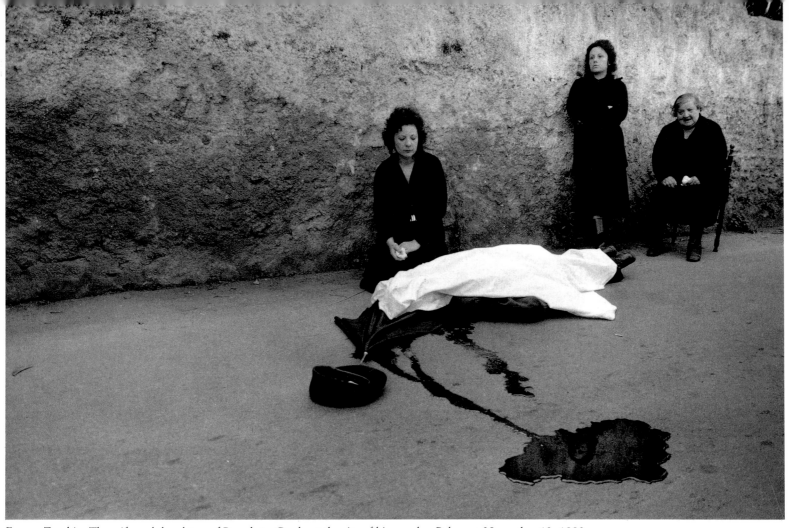

Franco Zecchin, The wife and daughters of Benedetto Grado at the site of his murder, Palermo, November 12, 1983

Franco Zecchin, Corpse of Ignazio Pedone left in front of the *carabinieri* station, August 6, 1982

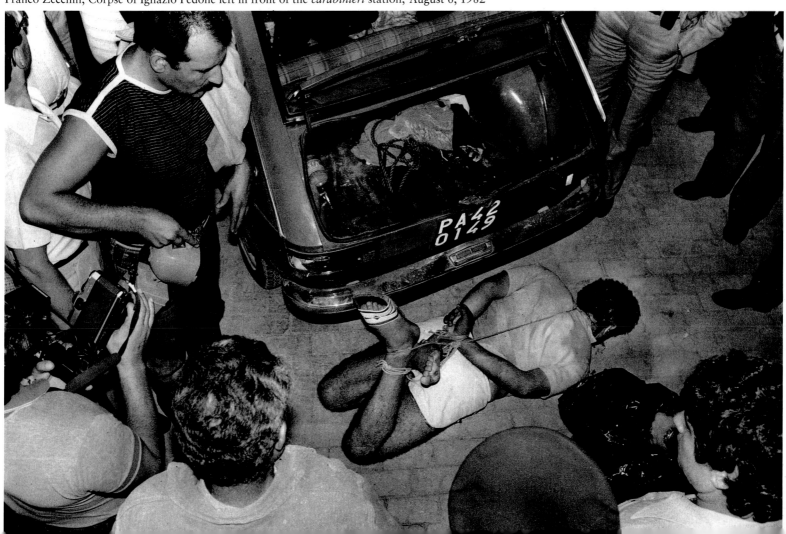

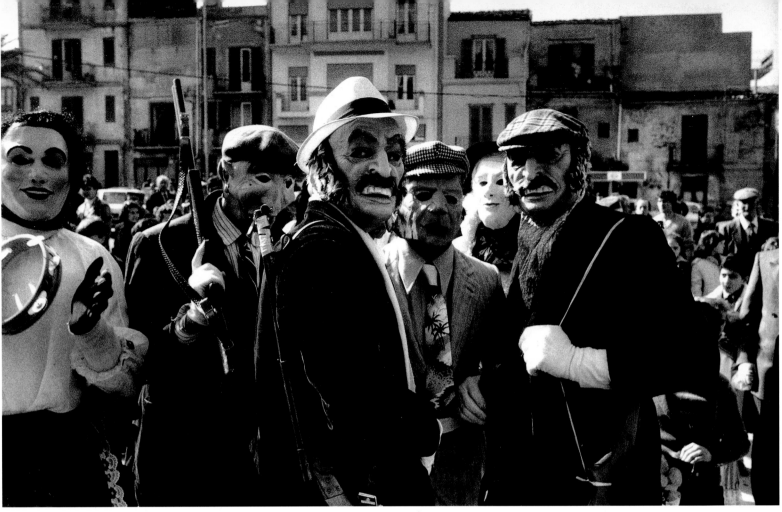

Franco Zecchin, Young men dressed as mafiosi at Carnevale, Corleone, Sicily, 1985

Franco Zecchin, Mafia drug trial, Palermo, November 29, 1982

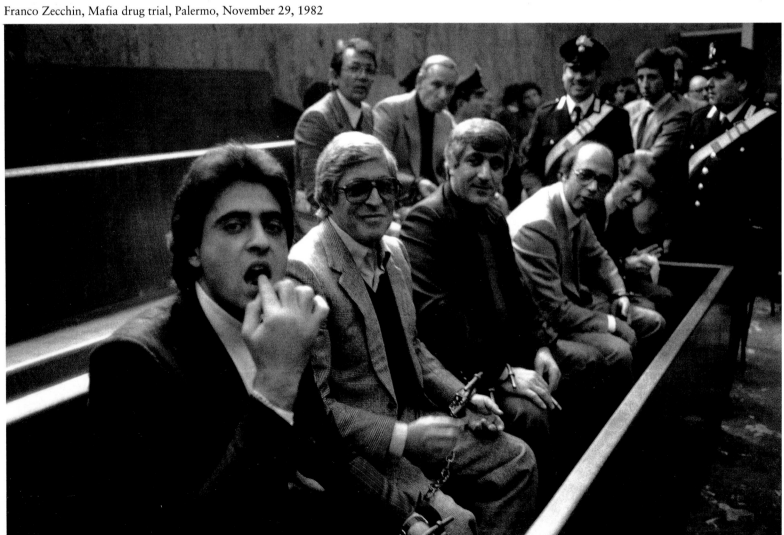

1909; of Don Calogero Vizzini; of Giuseppe Genco Russo; of the uncontested Mafia heads of the period between the two wars, between the pre- and post-Fascist periods. Deferred to by political leaders, these "respectable" and respected capos impassively ordered their cutthroats to carry out assassinations of trade unionists (who, in accordance with the conditions of deliverance that socialism prescribed, organized peasants and miners) because the union members might antagonize the feudal system, and might free themselves from the Mafia's grip. There were innumerable assassinations of these trade unionists, both during the economic crisis that followed World War I, and also in the period after World War II, when the peasant movement resumed its struggle to obtain the much-desired land reform from the government, which would call for redistribution of the uncultivated acreage on the landed estates.

With the rise of Fascism, the Mafia was repressed—there cannot be room for two Mafias. Many mafiosi were arrested, brought to trial, and interned, while others were forced to serve time or to emigrate clandestinely, mostly to the United States (see Christopher Duggan, La mafia durante il fascismo). Ironically, the harsh and indiscriminate police action taken by prefect Cesare Mori contributed to the sanctification of many mafiosi as antifascists. When the Fascist regime collapsed, these people returned to Italy—many followed the American troops that liberated the island—to take command in even stronger, more secure fashion than before, aligning themselves with—or forming—the political class that has governed postwar Sicily and Italy until today. The massacre of the peasants in Portella delle Ginestre on May 1, 1947, carried out by the bandit Salvatore Giuliano under orders from the Mafia, confirmed the definitive defeat of the peasant and worker movement, and announced the triumph, after the 1948 elections, of the Christian Democratic party and of the Mafia, which allied itself with that party. The mysterious murder of Giuliano was the first of the new democratic state's innumerable secrets, a cover-up that will most likely never be explained.

I have so far spoken of the historical Mafia, the archaic Mafia of the rural countryside and landed properties, a monarchic and absolute organization led by a single absolute and uncontested head, a patriarch who managed to die in his own bed and, like a king, to designate his own successor. This "romantic" mafioso Eden vanished with the end of the landed estates, with the devaluation of agriculture, with the birth of regional autonomy, and with the postwar reconstruction and consequent real-estate boom in the large cities. In 1937 Sciascia wrote prophetically: "If they succeed in migrating from the landed estates and consolidating themselves in the cities, if they succeed in coagulating around the regional bureaucracies, if they succeed in infiltrating the process of industrialization of the island, then this enormous problem will still be with us, and for many years." The landed monarchic Mafia disappeared, but was replaced by an urban, entrepreneurial dictatorship, in the big business of public works contracts. The leaders of this new Mafia, who from time to time were supported by various political powers, were corporals who established their authority solely through terrorizing society with weapons and unspeakable violence; the new, merciless Mafia heads would suddenly be dismissed and replaced, beneath the boom, not of the sawed-off shotgun as before, but of the submachine gun and TNT. And the terrain, the climate in which the Mafia operated, was exactly like that described by Ulloa in 1838—one of ironclad and increasingly close relationships between the "Onorata Società" (Honored society) and the political forces of the regional and central government, with the protection of the police and the magistrature. The men who took power in Palermo, and therefore in Sicily, were ready for anything; sly and pitiless, they didn't obey any ancient Mafia code. Indeed, the only language they spoke was the roaring, devastating one of the kaleshnikov and explosives. It was a long, ruthless dictatorship, aimed against anyone who opposed them: enemies, friends who were disloyal, forces of the state; like the dictatorships of Hitler, of Mussolini, or of Franco, this was the dictatorship of Corleone's Luciano Liggio and Salvatore Riina, of Mafia families such as the Provenzanos, the Bagarellas of Badalamenti, the mobsters Inzerillo, Bontade, Greco, and Madonia from Palermo.

The ruthless tyranny of these years was nurtured and supported by big business and by drug trafficking, followed by arms trafficking, and money laundering and its recycling into "clean" commercial and industrial enterprises. This Mafia was never restricted to its island borders (the relationships with the American Mafia were longstanding and constant)—entrepreneurial necessity caused it to spread rapidly to the rest of Italy, throughout Europe, and internationally, both west and east. And this modern Mafia, this empire, has established increasingly close, tenacious relationships with secret state apparatuses, with mysterious economic-political lobbies, clandestine Masonic associations. This is the modern Mafia that, in recent years, has killed, in cold blood, police officers, judges, political figures, and businessmen. But now, for the first time, a new and defiant breed has arisen in Sicily, willing to show its opposition, willing to fight back. And they have fought with a rational, almost scientific awareness of the Mafia's essence and consistency; they understand the way it works, its body and its many branches. General Dalla Chiesa, the judges Chinnici, Falcone, Borsellino, to name only the most famous victims of this Mafia, have taken the place of the trade unionists of times past, who opposed the Mafia in the name of justice, of democracy, and of civilization. These men opposed the political forces, both obvious and hidden, the state organisms, both national and otherwise, that have maintained shameful, secret ties with the Mafia.

It is estimated that nearly three hundred mafiosi have themselves turned against the Mob, with the advent of an effective witness-protection program modeled on the American system. Salvatore Riina—the "boss of bosses" who started out as a hit man for Liggio—was arrested in January of this year. Police had been seeking him for twenty-three years. The arrest of such a central figure offers some hope; it may signal the beginning of a new era, a new page in history.

Translated from the Italian by Marguerite Shore

AGAINST THE ODDS

ONE WOMAN'S BATTLE WITH THE MOB: AN INTERVIEW WITH LETIZIA BATTAGLIA

BY GIOVANNA CALVENZI

> " I believe that today Palermo presents an example of incredible courage: the Palermitani hang sheets in their windows as a symbol that means 'I am against the Mafia. I live here. You can come and cut my throat— I will always be against you.'"

For many people in Sicily and elsewhere, Letizia Battaglia is both a point of reference and a solid certainty as a photographer and as a person. If a coherent description of her can't be unraveled from the various stories one hears, it can be said that she has become a symbol—of the struggle against the Mafia, of course, and of the intelligent and refined use of photography as an instrument in this struggle. But this is not enough. Battaglia's story is that of an amazing woman—passionate, rebellious, cultivated, and curious—who uses the camera as one of the many means of being in contact with people, of sharing their desperation and their joys— a means of living.

"I was born in Palermo, which means something entirely different from being born in any other Italian city. I was born in a time of peace, but soon enough the war came along. My father was a seaman, and my childhood was spent traveling around Italy, dodging bombs, from Civitavecchia, in Trieste, to Naples. I went back to Sicily when I was ten.

"At sixteen, I felt unable to put up with my father's authority any more, and I decided to marry the first man who came along. I thought that might be the road to freedom. So I got married, and naturally, it was a total disaster. I felt constrained; I wanted to go back to school, but that just wasn't done in those days. Finally, I understood that with that man I would never be able to build an interesting future for myself. Inside, I had begun to have a sense of 'social' responsibilities, and my need to get out of that marriage grew. Finally, I did get away. I asked for no alimony and I had my three daughters with me…we had no money, no house, nothing.

"We moved to Milan, and that was the beginning of a very rough period. I began working with various newspapers, and became a correspondent for the Palermo paper *L'Ora*, in order to be able to support myself and the girls. After three years I also began to take photographs, out of necessity, to earn more money. I realized that I really liked photography. *L'Ora* asked me to come to Palermo to organize their photography service. I had met Franco Zecchin in Venice some months earlier. He became my companion, and still is after nearly nineteen years."

In Palermo, Battaglia worked in a dire reality, struggling to pay the small group of courageous photographers that made up the staff of *L'Ora*, who were covering all the local current events. They worked very hard, and the days were fraught with anxiety and fear. "It was a group of heroic people who, despite a need to survive, were seeking in photography the chance to share with the people their pain and joys, which had called us to the medium. We were the newspaper: in one afternoon we might photograph the crowning of a beauty queen, a collapsed house, and a murder. Our field of action was the life of a city—a sad, savage, and also joyful city."

Battaglia, Zecchin, and the other photographers of *L'Ora* became champions of the oppressed and the exploited. Their subjects were Palermo, death, politicians, corruption, and violence. "We had our studio in a spot that other Italian photographers referred to as 'the cave,' because it was rather dank, and there were rats running about."

After a few years, the national weeklies began asking for their images—both Battaglia and Zecchin having become synonymous with "photography and Mafia." Life in Palermo was getting more and more difficult. In 1979, when the Mafia murdered a left-wing activist, Giuseppe Impastato, Battaglia and a group of others started the Centro Siciliano di Documentazione Giuseppe Impastato (Giuseppe Impastato Sicilian Center for Documentation), and started to use photography to denounce the Mafia head-on.

"We began having shows on the Mafia and on the whole Sicilian situation, dealing not only with murdered people or those who had been arrested, but also showing the faces of politicians who hadn't yet been accused of collaborating with the Mafia. We went all over Sicily with these exhibitions. One Sunday morning in Corleone, the home of the Mafia head Luciano Liggio, we put up a show that included a photo of Liggio's arrest. In about two minutes the entire piazza emptied out: people were terrified that they might one day be pointed out as accomplices to our photographs."

Those were very hard times. "We had some problems," Battaglia says, and seems to prefer not to speak about the insults, the curses, the threatening letters that were part of her life in Palermo. She

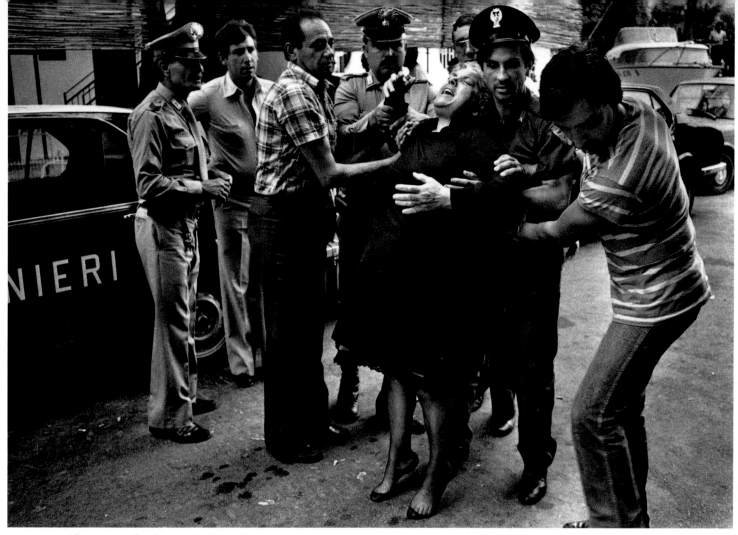

Letizia Battaglia, Sorrow for the murdered son, August 8, 1980

Letizia Battaglia, Murder of the secretary of the Christian Democratic party, Michele Reina, Palermo, March 9, 1979

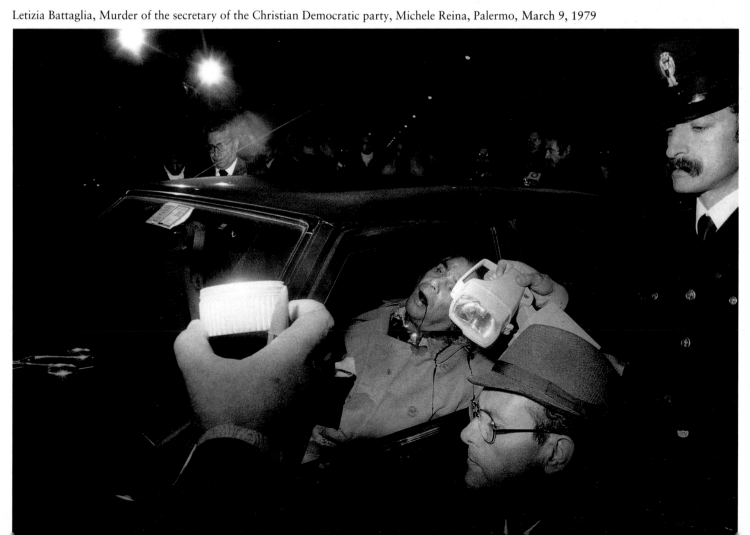

courageously continued living there, without friends, without a sense of being a part of society, constantly stabbing away at the monster that was smothering the city.

"On July 29, 1983," says Battaglia, "[the Mafia] killed Judge Rocco Chinnici, and I was asked to go and take pictures. I finally said, 'I've had it. I'm not going. From now on, I'm not going to meet death, to photograph death.' Little by little, I had been developing the idea that I wanted to, and should, involve other people, and that we would have to work together to fight this violence, which was by then absolutely unbearable. I continued taking photographs but began to feel a need to do something else as well.

"Then, in 1985, I was awarded the W. Eugene Smith prize. To me, it showed that my work was doing something worthwhile. No one in Palermo—no one in all of Italy—had ever said, 'This person is bearing witness to something important.' People were very uncomfortable with our presence with cameras. At the paper, we were treated like the paparazzi. When I was given that award, it really moved me. I cried—not because my photography had won a prize, but because it meant that in some other part of the world, someone understood the work we were doing in Sicily."

At the same time, Battaglia was becoming actively involved with politics. She joined a newly emerging Verdi, or Green party, whose struggles and objectives she shared. She ran for office and was voted in as a member of the city council. The mayor of Palermo at the time was Leoluca Orlando, a Christian Democrat, who waged a fierce battle against corruption within his party. For Battaglia and others, it was a period of very hard work and of a desperate love for the city and its people.

In 1989, the photo service of *L'Ora* closed, the paper changed hands, and the new owners were reluctant to employ a photographer with such a weighty political role. Battaglia stopped taking photographs; she was thoroughly absorbed in her political activities and had no desire to be a photographer only in her spare time.

When Orlando quit the Christian Democratic party, Battaglia decided to join his fight and entered a new political group, the Rete (Network). Today, she is a councilwoman for the Rete, as well as a member of the Sicilian parliament.

"Things are changing," she says. "It happens slowly. In the early years, we felt terribly alone, but then the Centro Impastato became a concrete reality. Then came women against the Mafia, workers against the Mafia, students against the Mafia . . . but despite this strong resistance, a political class that powerful, corrupt, and violent could not be defeated. When the Mafia killed the judges Giovanni Falcone and Paolo Borsellino, the city was up in arms. Maybe we will always be losing the fight, but Palermo is no longer accomplice to the Mafia, the people have begun to understand. We are beginning to work together, and that gives some meaning to the years of trouble and hardship and pain. I believe that today Palermo presents an example of incredible courage: the Palermitani hang sheets in their windows as a symbol that means 'I am against the Mafia. I live here. You can come and cut my throat—I will always be against you.'

"These are vitally important things. It's not easy to understand—to live in a city dominated by the Mafia means to have it in your home, in every family. Your kids' teacher, your downstairs neighbor, your brother. Anyone can be involved—and you don't know it. We are just beginning to know who the big bosses are. And so it's very important to be there—to love being there. I consider myself downright fortunate to be able to live this experience of resistance to injustice."

Indeed, precisely because things are beginning to change, Battaglia has made herself a promise: another four years of political activity, then, at the end of her term, she will not run for office again. "When I leave politics, I'll take up photography again. I'll start over, but not in Sicily. For now, however, I am still too much in love with this situation—I'll need four more years. If you are on the firing line, but it's somehow useful that you be there, you stay there." In Palermo, Battaglia is known by everyone, recognized in the streets, admired for her courage, her clarity, her tenacity. With the money she has earned as a councilwoman ("It's a lot," she says, almost awestruck), she pays other people's rent and telephone bills; she has opened a space for a little theater, a place for musical productions by women; she is one of the backers of a monthly magazine called *Mezzo Cielo,* also managed by women, for women involved in politics, journalism, and ecology. I like to be able to give more power to women, because they still have not been able to take what is rightfully theirs. In the Sicilian parliament, for example, out of ninety members, only two are women. . . . In the next years, I want to encourage other women to go and occupy the 50 percent that by right and duty belongs to them."

But that's not all. If she has momentarily set photography aside ("Photography is a huge commitment, to be there and to participate in the situation you are witnessing," she says), Battaglia is also committed in other areas. Every year she puts together a theatrical performance, not with straightforward, canonical texts, but using a collage of the work of various writers, along with testimonies and confessions, a performance by women using words and dance: using the potentials of feminine sensuality.

The day after Giovanni Falcone's funeral, Battaglia started a little publishing company called Edizioni della Battaglia. "After Falcone died, a girl named Beatrice Monroy wrote a testimonial of the funeral—'Palermo in tempo di peste' (Palermo in a time of plague)—and I thought it should be published. Since then, we've published a dozen or so titles—all courageous voices that mustn't be lost. It's very important that these examples of heroism live on; they prevent us from forgetting that there might be a different future for us."

In four years, she says, Palermo will no longer need her, and Letizia Battaglia will go back to being a photographer. Just a photographer? No one believes that, but she has to think it will be true, that she will at last have the time and concentration necessary to dedicate to one of the great passions of her life.

Translated from the Italian by Diana C. Stoll

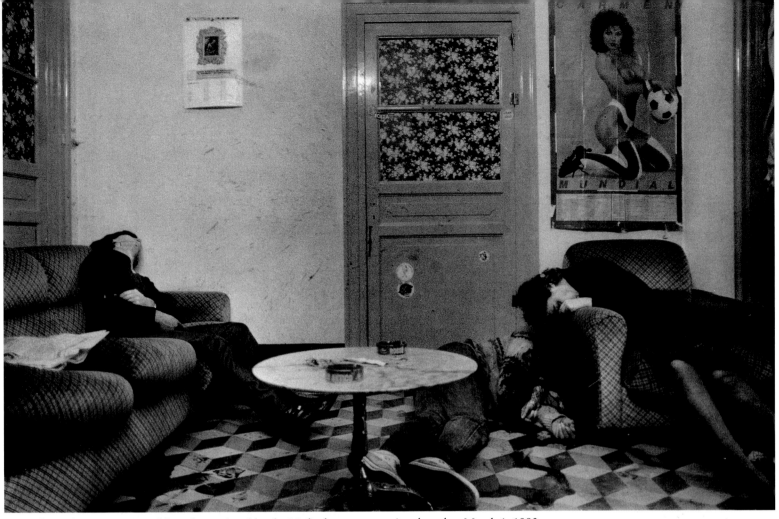

Letizia Battaglia, Prostitute and friends murdered by the Mafia for not respecting the rules, March 1, 1983

Letizia Battaglia, Woman watching the funeral of communist representative Pio La Torre, Palermo, May 5, 1982

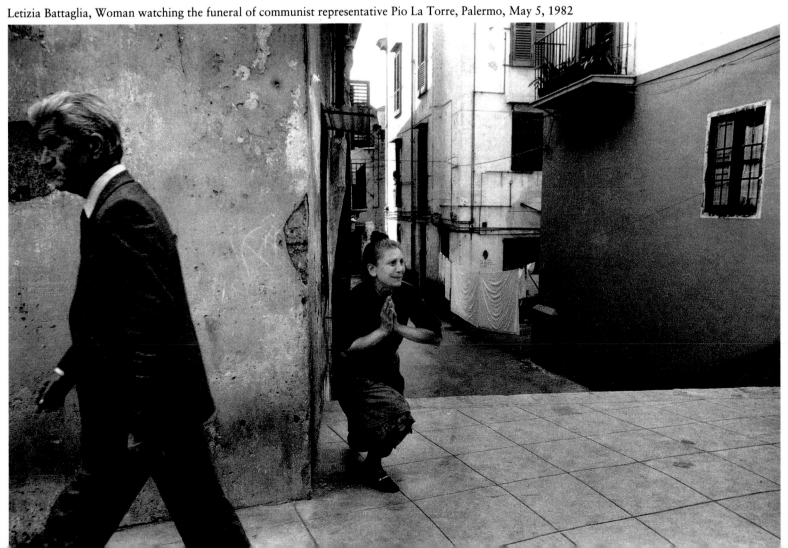

THE INVENTION OF SOUTHERNNESS

PHOTOGRAPHIC TRAVELS
AND THE DISCOVERY OF THE OTHER HALF OF ITALY

BY ANTONELLA RUSSO
with research by Diego Mormorio

Mimmo Jodice, *Centro antico* (Old town center), Naples, 1988

Throughout the history of Italy, the South—an umbrella term covering Abruzzo, Campania, Basilicata (formerly Lucania), Puglia, Calabria, and Sicily, has been considered a too-distant and altogether foreign country. The notion of the South filled in for a diversity of categories, most of which helped depict an otherwise unknown and unrepresentable region; this *bassa Italia* ("low" Italy), this "Italian India" (as it was referred to by sixteenth-century Jesuits, who thought they could train themselves for life in the wilderness of the West Indies in Italy's South), came to be perceived as a reservoir of archaic cultures and costumes, and of inaccessible languages.

The configuration of the "other half" of Italy relied upon a series of vastly contrasting descriptions and on topoi of excess: inhospitable wild woods paired with inviting picture-perfect bays; unbearably hot weather in regions filled with equally hot-tempered people; urban streets populated with urchins and imaginative, colorful vendors; memorable Mediterranean sites decorated by von-Gloedenesque, ravishingly healthy youths. Former home of brigands and present haunt of the Mafia, the South, in its "excesses," seems to have always worked to trouble the dignity of Italy's past traditions and to disrupt an otherwise uncontested advancement of "high" Italy into history's scenario.[1]

Most of the picturesque representations of Italy's South came into being in the eighteenth century, forged by foreign artists, poets, and gentlemen on the Grand Tour of Europe, and were circulated throughout the continent in sketchbooks, journals, and literature.[2] Drawn to the South of Italy by the discovery of the buried cities of Herculaneum and Pompeii, many of these travelers ventured south of Naples, through Calabria into Sicily, following a new and reversed itinerary to rediscover the world of classical antiquity and "to recover the site of mythic Hellas."[3]

Today, Goethe's *Italienische Reise* still remains a paradigm of the picturesque and romantic mode of viewing, sketching, imaging the South, a mode that informed much of the eighteenth and early nineteenth centuries. Goethe marvels at a South that discloses its natural wonders in a delirium of enchanting panoramic views, much like a photographic diorama—a phantasmagoria of colorful natural scenes.

It was in Sicily that Goethe believed he had found the long-sought *Urpflanze*, the origin of the vegetable world. For Goethe, "Italien ohne Sizilien macht gar kein Bild in der Seele: hier ist erst der Schluessel zu allem" (Italy without Sicily leaves no image in the soul: here is the key to everything).[4]

If the eighteenth-century picturesque voyage fostered private images of southern Italy, the early-nineteenth-century dawn of the tourist industry turned traveling south in Italy into a public commodity, highlighting its exoticism and promoting its colonization. Topical southern sunny views, landscapes as photographers' backdrops, and genre pictures of southerners, helped to inaugurate a new geography of stereotyped images: an exemplary itinerary of

Ferdinando Scianna, *Enna*, 1962

58

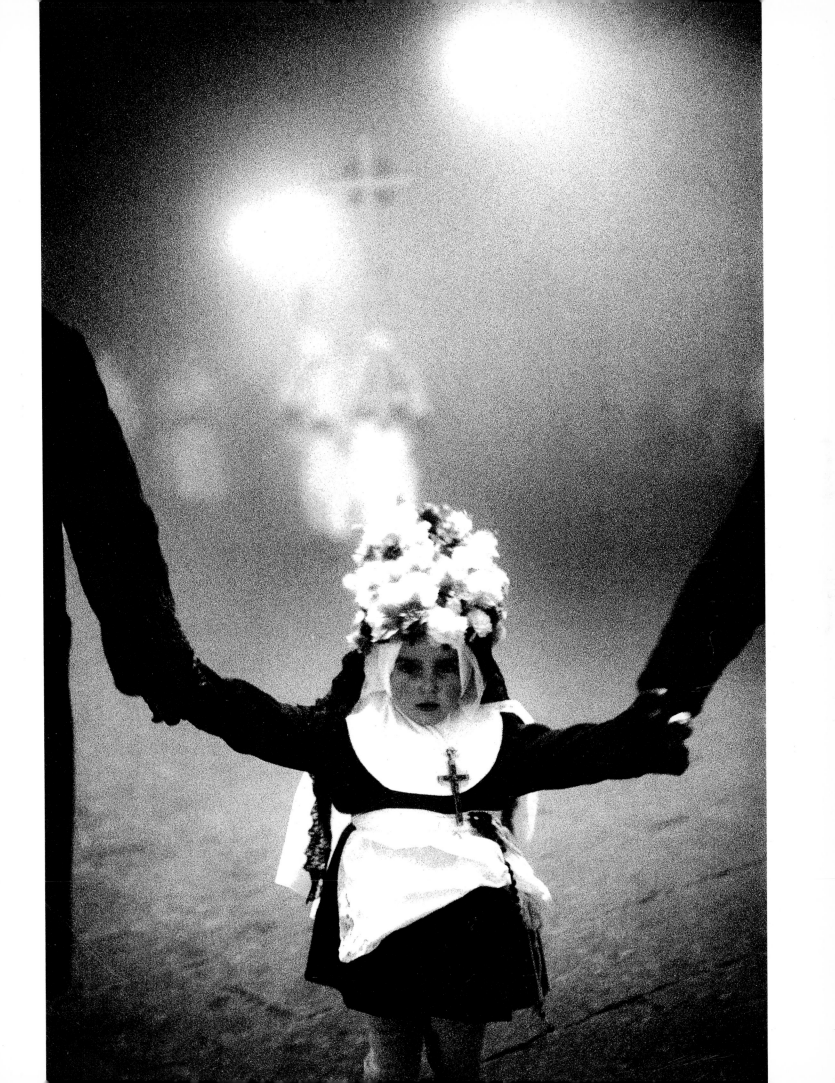

commonplaces that still shapes the current concept of southern Italy.[5] A new army of foreign photographers operating in Italy—Giorgio Sommer and Alphonse Charbonnier among others—worked for the emerging "souvenir-picture industry," bringing images of the Amalfitan and Surrentine coasts, the bay of Naples, Capri's Blue Grotto, and smoking Vesuvius right into hotel lobbies, where they set up their shops.

In the thirties, the locus of the South came to function as an isolating prison, a natural solitary confinement severing intellectuals from the rest of Italy. In 1935, the writer Carlo Levi was exiled to the South because of his antifascist political activities. In his book *Christ Stopped at Eboli* (published in Italy in 1945), Levi depicts a desolate Lucania: an inland territory as a cultural wall separating the local peasants from the rest of the country, while poverty and isolation hold them in a hell of superstition, ancient rituals, and a life carried out as directed by an ominous destiny.[6]

Levi charted a South that had been ignored by the Grand Tour map and tourist itineraries, and gave representation to the day-to-day struggle of the Lucanian peasants, condemned to isolation, and to the hostility of their unyielding lands. "No one had come to this land except as an enemy, a conqueror, or a visitor devoid of understanding. The seasons pass today over the toil of the peasants, just as they did three thousand years before Christ; no message, human or divine, has reached this stubborn poverty [...] But to this shadowy land, that knows neither sin nor redemption from sin, where evil is not moral but is only the pain residing forever in earthly things, Christ did not come. Christ stopped at Eboli."[7] As historian Giuseppe Giarizzo notes, "Levi's *Christ Stopped at Eboli* became the palimpsest of southern Italy's intelligenstia." Together with the republication in 1947 of Antonio Gramsci's *La Questione meridionale,* Levi's book helped to refuel the political debate over the necessity of a struggle for the cultural and political unification of the two separate halves of the country in post-World War II Italy, and focused attention on the desperate isolation of southern peasants, kept at the margins of the country and of history.

In 1948 Marxist ethnologist Ernesto de Martino set out through Levi's Lucania on a mission to investigate the peasants' religious/magic practices and rituals, in an attempt to document the complex-

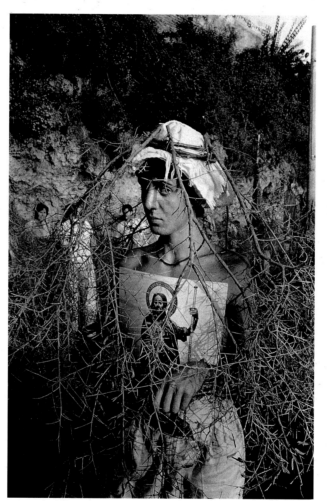

Marialba Russo, *Processione degli spinati* (Procession of the thorned ones), Calabria, 1980

ity of their beliefs, and thus to contribute to a historicization of these cultures and customs. All of de Martino's missions were documented with photographs, the earliest of which were provided by Franco Pinna and Ando Gilardi.[8] Moreover, some of these anthropological studies were, in fact, specifically initiated by photographs documenting archaic rituals.[9]

Photography was a tool for de Martino in the fight against what he calls a "crisis of presence" for southern Italian peasants—the seeming inaccessibility of participation in contemporary society—a tool with which to catch them as they were struggling against history, to help them to record their own cultural memory and enter history "breaking the borders of Eboli." For de Martino, the importance of a vernacular folklore laid in the possibility it provided to turn those people into protagonists of their own world, allowing them to write their own autobiography, to become conscious of the culture they engendered. What de Martino calls "progressive folklore" is a cultural entity that neither idealizes the peasant world nor fosters the growth of irrationalist mythology. Instead, it documents a culture and a system of beliefs that upset a bourgeois tendency to erase what is thought of as an "inferior social condition, one which allowed the anachronistic perpetuation of relics of archaic cultures."[10]

In the fifties, such attention to popular cultures was part of the program that was to unify the country; Gramsci and the Italian Communist party had proposed a "cultura nazionale" that was to eradicate the distinction between *alta* (high) culture and popular, *bassa* (low) culture. Ethnologists and photographers turned to the South for documentation of older cultures, primitive magic rituals, and a whole cultural system, for future foundations of the new "national-popular culture" that would help unite two struggling peoples: the southern peasants and the industrial working class in Northern Italy.

Despite the romantic haze surrounding this political project for peasants' emancipation from historical obscurity, the publication of de Martino's studies spurred a number of young photographers to look south and explore inland territories down at the bottom of the Italian peninsula, in a series of explorations into folkloric costumes and religious ceremony, along with the daily life of rituals with no mythology.

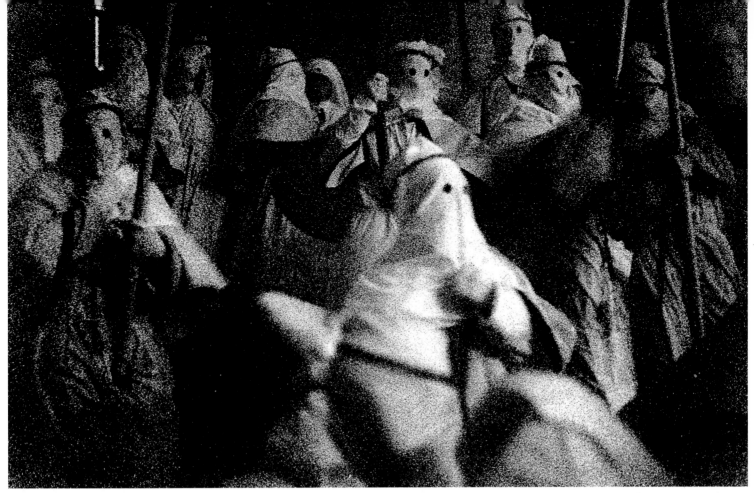

Ferdinando Scianna, *Enna*, 1962

Left: Marialba Russo, *Il Parto* (In labor), 1979; *right*: Marialba Russo, *Processione di penitenza*, (Procession of penitence), Calabria, 1981

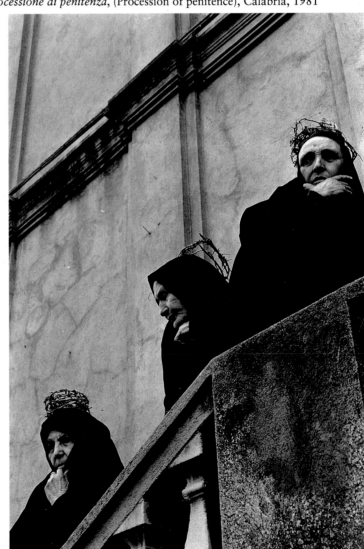

Among the early "literary missions" to recover an image of the other half of Italy stands *Conversazione in Sicilia,* a novel by Elio Vittorini. Written in 1938 and published for the first time in 1941, the book was republished at the end of 1953 in a new edition, with photographs by Luigi Crocenzi and a selection of images dated 1938 by Giacomo Pozzi-Bellini.[11] It was one of the first novels published in Italy to be accompanied by photographs depicting the interior of Sicily and proposing a tougher Sicilian existence, as well as by details of artworks that are part of the everyday Sicilian landscape. Vittorini himself directed the photographers and placed the images alongside the text. Each photograph in the book "reflected and reverberated upon the others, modifying both its own meaning and those of the accompanying images."[12]

A similar exploration into the texture of southern culture and territory was that of Fosco Maraini. This prominent Italian intellectual began his trip down South in 1951. He began his own photographic campaign to gather material for a book ostensibly to be published in 1951, entitled *Nostro Sud* (Our South), but which was not published until 1980, under the title *Civiltà contadina* (Peasant civilization).[13] Maraini photographed for three years, in a comprehensive way, not only the familiar southern sights and landscapes but also interiors, faces, and images that represented rituals of daily life, those pictures that he understood as "occasions for *quotidianità*" (everydayness), invented by southern Italians.

By the late fifties Mario Giacomelli had toured Scanno in Abruzzo. His photographs of the little village, with its inhabitants cloaked in their black costumes, traveled all over the world. These images documented Giacomelli's fascination with southern archaic conditions and their fabulistic atmosphere. Notwithstanding the harsh comments of Italian critics, which singled out the "Scanno" series as sheer "formalist" and "calligraphic" exercise embedded in a "trite southern rhetoric," Giacomelli continued his travels, and in the same period produced a series of photographs on the Puglia region. Like "Scanno," these later photographs were of no ethnological use, but rather captured crowds of houses, endlessly repeating their poor materials and basic shapes, as though squeezing themselves into the image, stretching the very edges of the frame. Giacomelli records a choreography of responsive glances of street children, and wary faces of young mothers, who are both intrigued and concerned with the photographer's attention.

Enzo Sellerio, the first contemporary Sicilian photographer to gain an international reputation, explored a Sicilian landscape devoid of romantic rhetoric. Sellerio began photographing in the early fifties, producing images in which he tried to overcome the stereotyped picture of the South, and the conventional desolate representations of southern daily life. His excursions into the poorest areas of downtown Palermo reveal a certain Sicilian esprit, a peculiar instinct or will to go through everyday life armed with irony, a self-imposed distance. His most famous photographs, taken from the early fifties to the mid-seventies, were later published in 1977 in his *Inventario Siciliano* (Sicilian inventory). Commenting on Sellerio's photographs, Leonardo Sciascia states: "The specific human reality that was spotted, pursued, and finally surprised by Sellerio, as in a strenuous and laborious hunt, presents an alert and stubborn resistance, made of superstition and shame, a resistance to yielding to a photographic eye and above all to being caught while signifying. . . . These photographs are thus in a way 'forms' of a life almost un-graspable and refractory in itself. They narrate and signify Sicily with truth and fantasy (as there is no truth without fantasy) and they belong to the best literary and figurative tradition of the island."[14]

Ferdinando Scianna caught the attention of the photography world in Europe in 1965 with his book *Feste religiose in Sicilia.*[15] It included some hundred images, which the photographer took during a sort of pilgrimage, following itineraries for some years of religious processions in Sicily. Although these pictures are still often read as anthropological documentation of the studies by de Martino, they are, rather, an archaeological study of the habits and postures of Sicilians; they constitute an investigation into Sicilianness, what Scianna himself defines as "a sort of autobiography through representations of people and things that I love and hate the most." Scianna's *Feste religiose* is a tragic look into a Sicilian mode of existence that is carried out and perpetuated through a complex collection of everyday gestures, continuous rituals: a veritable enactment of a Pirandellian play of simulation and dissimulation.

At the beginning of the seventies, following in the wake of a renewed political commitment fueled by the students' movement, the South was viewed and pictured as a locus of research and investigation into the folkloric, which seemed to revive memories of anthropological missions of the early fifties. By the mid-seventies, Marialba Russo was producing photographic works that explored a southern geography of the sites and spaces of religious festivals

Mimmo Jodice, *Napoli,* 1986

Above: Ferdinando Scianna, *Lentini, Siracusa*, 1963 *Below*: Ferdinando Scianna, *Sicilia*, 1963

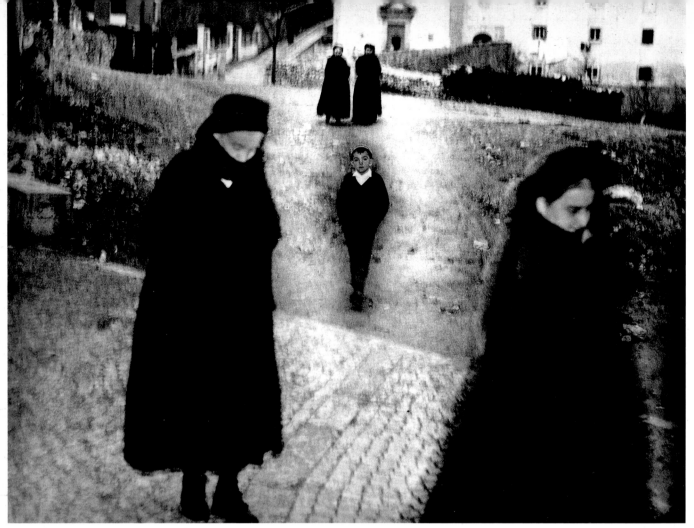

Mario Giacomelli, from the series "Scanno," 1957–59

Mario Giacomelli, from the series "La buona terra" (The good earth), 1964–65

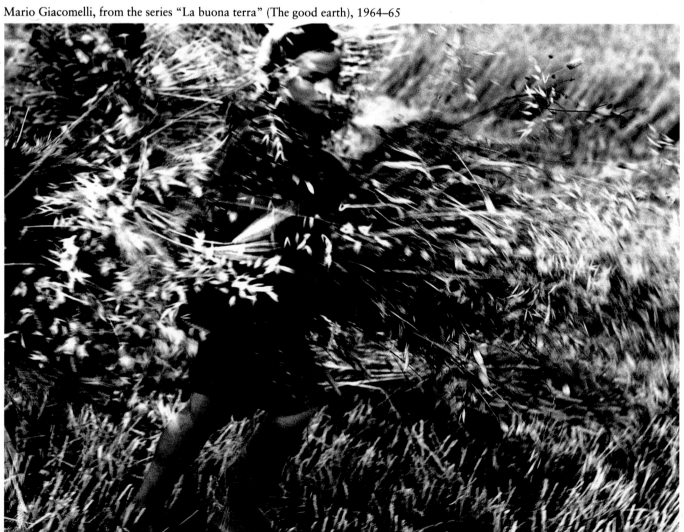

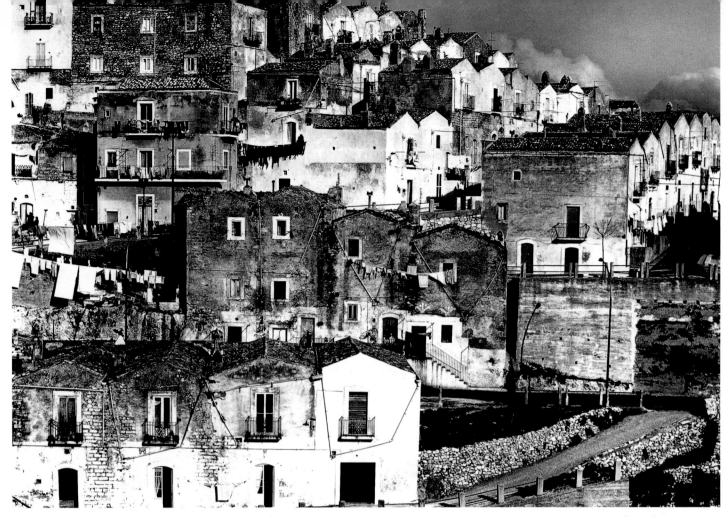

Mario Giacomelli, from the series "Puglia," 1958

Mario Giacomelli, from the series "Scanno," 1957–59

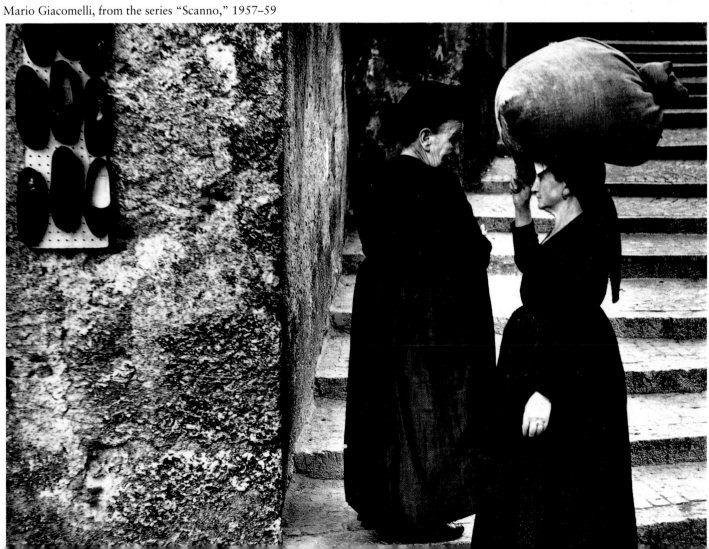

65

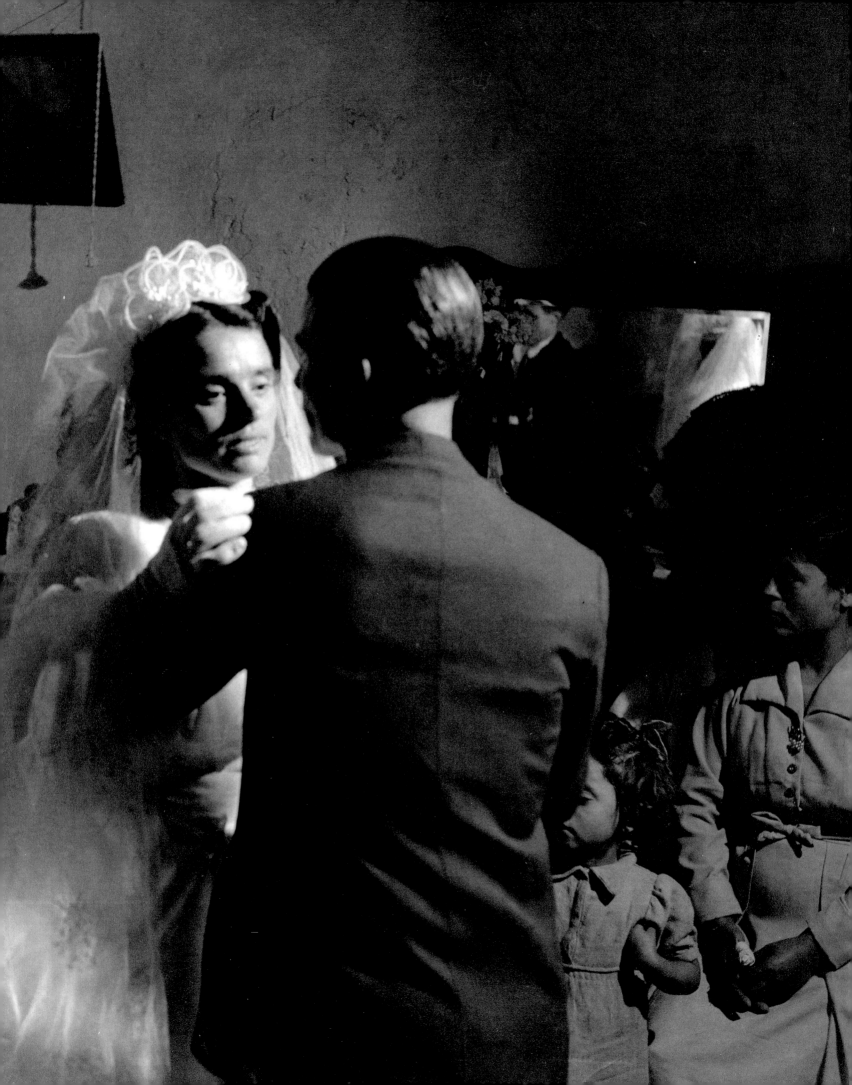

and rituals, a syncretism of Christian and pagan ceremonies. Some of her most successful photographs—such as those of men entangled in thorns, documents of mass self-flagellation, pictures of black-cloaked, thorn-crowned women—reflect on popular religious festivals as announcements of sexual repression. One of the most striking photographs taken during this period portrays a ritualistic enactment—by men—of the throes of labor, testifying to an ancient awe and fear of matriarchy.

To Mimmo Jodice, the South is a project to revisit cityscapes and landscapes long subjected to the colonizing gaze of the tourist industry, and to map out a geography of sites/sights that pertain to a Mediterranean culture. Jodice reexplores the tradition of Neapolitan *vedutismo* (view painting), according to which the city of Naples, as a metonym for South from the Quattrocento onward, was represented as an open and transparent site, displayed for view, readily accessible and identifiable. While Jodice's images openly challenge those conventional representations and genre pictures produced for Grand Tour travelers, they also disorient the viewer, presenting him/her with peopleless and labyrinthine al-

Enzo Sellerio, *Gela*, 1967

leys, cloudy panoramas and disquieting solitary marinas. Rather than recalling the genre of picturesque views, Jodice's photographs spur us to reconsider exploited views of Naples; they confront us with our own interior geography.

To Jodice, the South belongs to the vision of Mediterranean civilization—a place at the threshold of history and mythology, that space between form and hallucination. In his migrations throughout his Mediterranean, Jodice frames seascapes and coasts, bays and piers, archaeological sites set against wide open skies, endlessly tracing and retracing outlines and borders, working on an ever provisional travel map.

This South, cyclically toured as heavenly natural landscape, origin of all natural life, or searched and investigated as a reservoir of primitiveness, site of infinite rituals and a locus of folklore, is still viewed as a distant universe, a space exiled from history. A territory to be traveled by one who wants to explore absence, the South presents itself as yet another perfect picture of a bay, an inviting panorama endlessly advancing and receding in the loops of our imagination. To this traveler of absence, the South stands as that memory, that photograph to which one can always emigrate.

1. Antonio Gramsci underlined a current ideology laid out by northern Italian bourgeois propaganda, which viewed the South as "la palla di piombo che impedisce piu' rapidi progresso allo sviluppo civile dell'Italia" (the ball and chain that hold back Italy's rapid entrance into civilization) in Gramsci, "Alcuni temi della questione meridionale" in *Antologia degli scritti,* ed. Carlo Salinari and Mario Spinella, Rome: Editori Riuniti, 1963, p. 53.

2. On the topic of the Grand Tour through Italy, see the important essay and exhaustive commentary by Cesare de Seta, "L'Italia nello specchio del Grand Tour" in *Storia d'Italia,* vol. 5, Turin: Einaudi, 1982, pp. 127–263.

3. De Seta, "L'Italia nello specchio del Grand Tour," p. 233.

4. Johann Wolfgang Goethe, *Italienische Reise,* Frankfurt: Insel Verlag 1976, p. 328.

5. For an iconographic reading of the origin of the stereotype in view paintings, see Maria Antonella Fusco, "Il 'luogo comune paesaggistico' nelle immagini di massa" in *Storia d'Italia,* vol. 5, Turin: Einaudi, 1982, pp. 753-801.

6. See Carlo Levi, *Christ Stopped at Eboli,* trans. Frances Frenaye. New York: Farrar, Straus and Co., 1947. Of course, Levi was neither the first nor the sole author to deal with southern Italy's social conditions. Nineteenth-century southern writers, such as Grazia Deledda, Corrado Alvaro, and *verista* writers Giovanni Verga and Luigi Capuana, among others, wrote their literary masterpieces depicting the South and its universe. But whereas the work of all these writers was aimed at denouncing the ruthless behavior of landowners toward the peasants, Levi's book focuses exclusively on the peasants' conditions.

7. Ibid, p. 4.

8. See Ernesto de Martino, *Sud e magia,* Milan: Feltrinelli, 1959; Franco Pinna, *Viaggio nelle terre del silenzio: Reportage dal profondo Sud 1950–1959,* Milan: Idea Books, 1980.

9. Such is the case with *tarantismo* (ritualistic seizures so called because they were originally believed to be caused by the bite of the tarantûla). De Martino states that his early interest in this research was stimulated by photographs documenting this phenomenon. See de Martino, *La terra del rimorso,* Milan: Mondadori, 1961, p. 30.

10. De Martino, quoted in Giuseppe Giarizzo, *Mezzogiorno senza meridionalismo,* Venice: Marsilio, 1992, p. 210.

11. Elio Vittorini, *Conversazione in Sicilia,* Milan: Bompiani, 1953. Vittorini was a pivotal author of contemporary European literature and one of the first Italian writers to use photography in relationship with literary texts, in such works as *Americana* (1941) and in the magazine *Il politecnico.* Vittorini was the magazine's editor, as well as an editor at Einaudi in Turin. He was instrumental in introducing the work of many important American writers in Italy.

12. *Gli scrittori e la fotografia.* Diego Mormorio, ed., Rome: Editori Riuniti, 1988, p. 168.

13. Fosco Maraini, *Civiltà contadina,* Bari: De Donato, 1980.

14. Leonardo Sciascia, *16 fotografie siciliane dall'archivio di Enzo Sellerio,* Turin: Tipografia Torinese Editrice, 1969, p. v.

15. Scianna's *Feste religiose in Sicilia,* Bari: Leonardo da Vinci editrice, 1965, won the Nadar Prix in 1966. It was republished in Palermo: L'Immagine editrice, 1987.

Fosco Maraini, *Pittice,* 1950–51

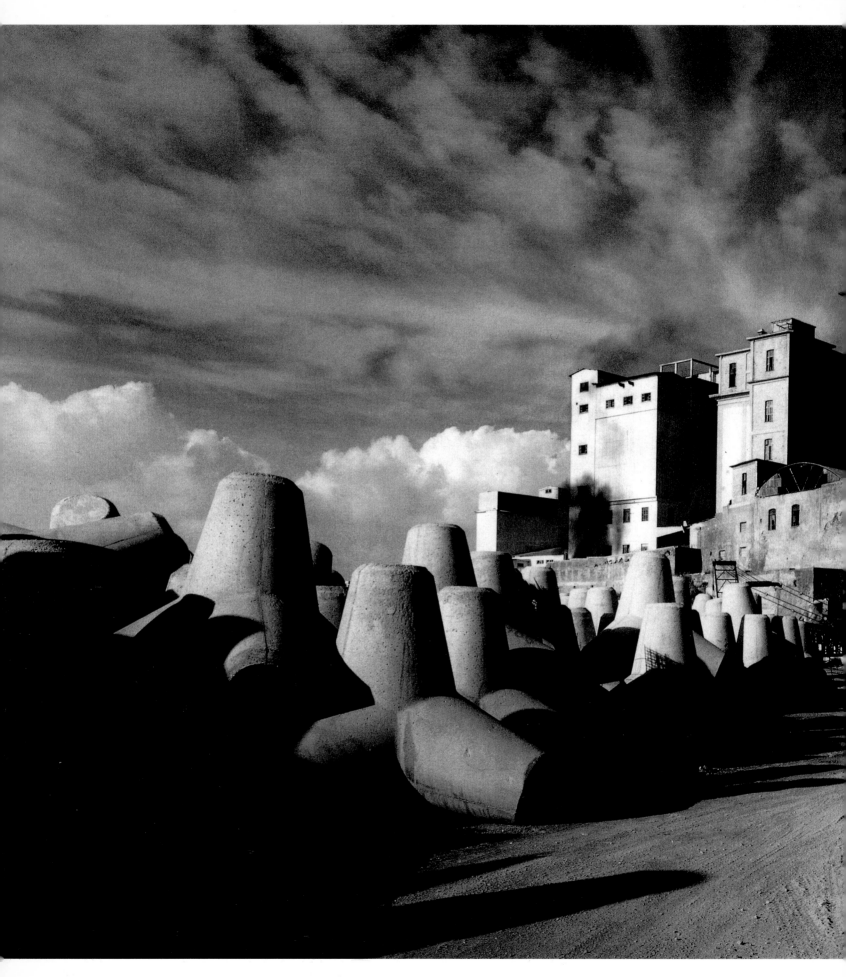

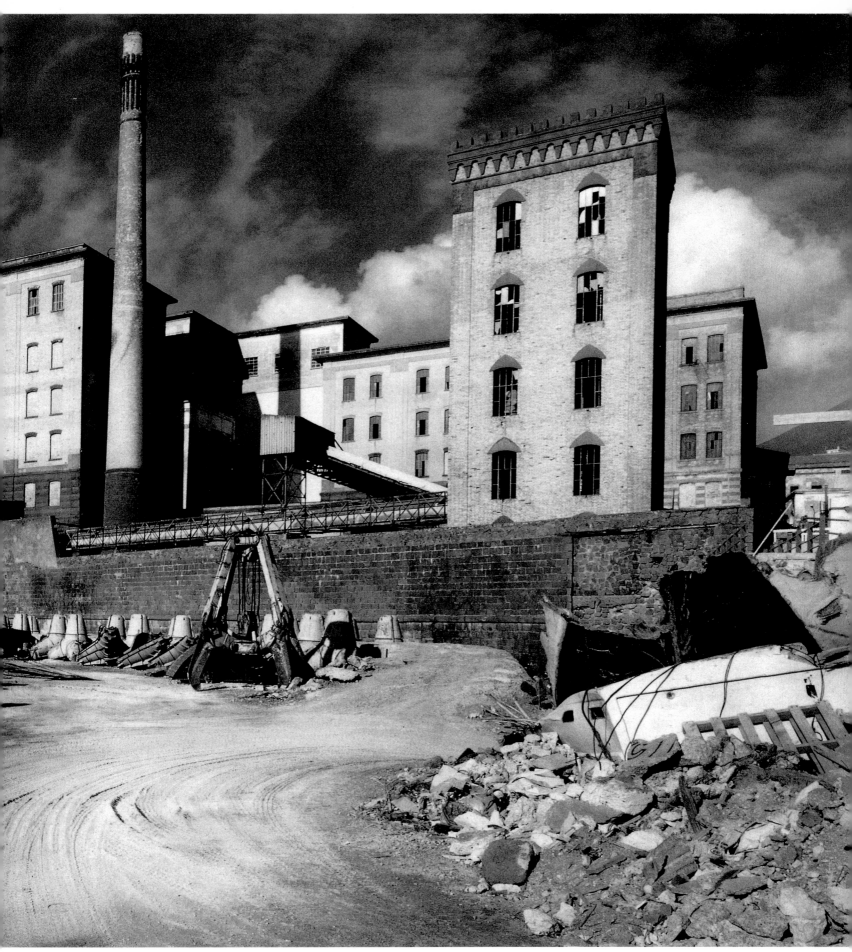

Mimmo Jodice, *Veduta di Napoli* (View of Naples), 1990

PEOPLE AND IDEAS

A SYMBIOTIC RELATIONSHIP:

Collecting and the History of Italian Photography

By Carlo Bertelli

In 1961 a short survey of the history of Italian photography, compiled by Lamberto Vitali, appeared as an appendix to the Italian translation of Peter Pollack's *History of Photography from Antiquity to Today.* An appendix was necessary, as Pollack's book scarcely gave mention of what had happened in Italian photography since the first daguerreotypes were made, as early as 1839.

In his book *The Rare Art,* Joseph Alsop makes the point that there could not be a history of art without art collecting. The evolution of Italian historiography bears this statement out: a number of historians were also collectors of the objects of their research. Vitali, for example, collected not only photographs, but also art and antiquities. In fact, it was his interest in a nineteenth-century painter, Federico Faruffini, that led Vitali to early Italian photography. Faruffini was also a photographer, and Vitali became interested in the medium after discovering and acquiring a number of his photographs. In 1935, he wrote a piece on Faruffini's work as a photographer for *Emporium,* an art magazine that Vitali himself edited.

Photography by painters, either for their own use, or—as was the case with Faruffini—to sell to colleagues (most frequently images of nudes for use as models), was not an uncommon practice in nineteenth-century Europe, but this activity had little to do with photography as a profession or as an art in its own right. While painters might demonstrate an aesthetic sensibility in their photographs, they remained ensconced in a world that centered on painting.

The true art of collecting—and that which first illuminated the evolution of Italian photography—was and still is best exemplified by the all-consuming passion of the *romanisti,* or devotees of Roman curiosities and history. In 1956 a distinguished *romanista,* Silvio Negro, wrote a fascinating book on the "Fourth Rome," which examined the Republican urbs in the imperial city, the papal metropolis. His book, entitled *Quarta Roma,* was the product of a lifetime of work. Informative and brilliant, it managed to gather the minutest details of Roman daily life from a variety of angles, giving a lively picture of a period of transition. Negro rediscovered a number of photographers active in Rome from the early 1900s and includes in the book particulars of their day-to-day lives, as well as images by these pioneers. (Negro was not the only *romanista* who was both a collector and a connoisseur. The archaeologist Valerio Cianfarani compiled a notable collection, as has Piero Becchetti, for example.)

Thus it was in studying the history of the last days of papal Rome that Italian photography began to be investigated as a historical phenomenon. This may seem surprising to those unfamiliar with Italian history: papal Rome was, after all, the center of a reactionary, theocratic, and medieval state. What role could photography possibly have played? As we well know from the experience of these final decades of the twentieth century, technological progress is not necessarily indicative of an advanced, "progressive" society. And so, one should be surprised neither that there were technological advances made in papal Rome, nor that it was seen as desirable, perhaps even expedient, to record this new technology and its most common applications through photography. Pius IX was especially pleased to have photographs of the new railways and steamboats (just as years later, Mussolini would use the medium to celebrate achievements in aviation, among other things). His

successors were equally open to photography: one ceiling in the Musei Vaticani introduces what is perhaps the first representation of a photographic camera made in fresco, painted by commission under Pope Leo XIII.

During this fin-de-siècle period, Rome was unquestionably the most cosmopolitan city in Italy. Nearly all the civilized states had their representatives there. Pilgrims, sightseers, and adventurers also came flocking to Rome, which was the inevitable goal of the Grand Tour. Tourism is, of course, a highly visual experience and, since the advent of the camera, tourists have been hungry for photographs. Furthermore, it seems that there was no event in Rome, no trace of her past, that did not seem photogenic to

> There could not be a history of art without art collecting. The evolution of Italian historiography bears this out.

someone—even the trenches and cannons of the 1849 revolution became the subjects of photographic reportage.

Italy also attracted art historians—the disciples of a new branch of research—as well as hordes of archaeologists. Soon, photo studios began to specialize in these particular areas of documentation, which were to occupy much of Italian photographic production for many decades. The pictures were not collected or made for the sake of photography, but as reminders, records of the original site or artwork. The photographers' skill was in remaining as anonymous as possible.

In the late nineteenth century and in the early twentieth, a new pictorialism was introduced into Italy, with a strong advocate in the magazine *La fotografia artistica* (founded in Turin in March 1909 by Annibale Cominetti). This new vision encountered its first enemies in the futurist avant-garde. Yet even attempts by the Bragaglia brothers at creating a futurist photography, based on Anton Giulio Bragaglia's theory of "Fotodinamismo," were dismissed by futurist Umberto Boccioni

Anton Giulio Bragaglia, *Change of Position*, 1911

and other artists. They refused to compromise the free-flowing, intuitive creativity they believed possible in painting and various other forms of visual expression, and therefore rejected photography, which they considered a systematic, "mechanical" art. This attitude coincided with the philosophical verdict against any sort of mechanical reproduction, in favor of a theory of art as original self-expression.

The industrialization World War I forced on Italy, essentially a rural country, was followed, after much violence, by the rise of fascism. If, as numerous modern historians see this and other dictatorships, Italy's Fascist period was a hurdle on the rough road toward complete industrialization, it must

be noted that Fascist propaganda was reluctant to exalt the industrial world. Instead, it encouraged artists and other citizens to perpetuate a bucolic image of Italy and ancient Rome—of which, according to the same propaganda, Fascist Italy was a glorious rebirth. Photography was recognized as a tool that could be utilized to support and facilitate the Fascist agenda, as well as to manipulate public perception.

During the 1930s a fresh appreciation of the contemporary and urban world developed in Italy, largely due to the very influential impact of American films. Soon a national Italian film industry started to emerge, and it happened that several individuals who had careers in film were ac-

complished photographers as well, notably the film critic Francesco Pasinetti and the director Alberto Lattuada. Other photographers, working alone or in groups that gathered in the industrial towns of the North, also began to take pictures for their own sake. Photography as a medium was truly beginning to take on a life of its own, and it was around this period that a burgeoning interest in collecting vintage photographs began to take hold. Italian photography, both past and current, was being recognized and valued as its own art, one that could flourish in a climate that would tolerate, and eventually embrace, the camera as a tool capable of producing images worth preserving and possessing.

IN THE MEANTIME:

Fashion Photographer Fabrizio Ferri Turns His Focus to Pediatric AIDS

ACQVA, photographs by Fabrizio Ferri. Published by Industria, 1992. ($50.00 — available in New York and Milan at Industria Superstudio, and elsewhere at stores carrying the Industria clothing collection. One hundred percent of all proceeds will be donated to the Pediatric AIDS Foundation).

Aperture: Were you commissioned to make *ACQVA*?

Fabrizio Ferri: For this particular job, I had no client and really no market. It was something that came right out of wanting to help the people at the Pediatric AIDS Foundation, which helps all of us. Not just the profits—all the money generated by *ACQVA* will go to the foundation.

A: Why did you decide on the Pediatric AIDS Foundation?

FF: This damn illness is not a punishment. And it's the only illness, deadly illness, that people still see as a punishment—and that attitude is really hurtful. It breeds discrimi-

Photographs by Fabrizio Ferri, from *ACQVA*

nation, and a sense of "us" and "them." When you focus on an organization like the Pediatric AIDS Foundation, you get involved with children who are infected. People perceive children as having no sin and no fault, and so they find it easier to be compassionate about AIDS, and are less prejudiced. I think if we begin by focusing on children, we may find a way to open up a larger discussion and get another message through, a message not to discriminate against drug addicts or gay people, or sex workers, or whomever—a message that nobody deserves this disease. We all were children once. It may remind us to treat all people equally, without judging.

The Pediatric AIDS Foundation is also an organization that has only 5 percent overhead. Ninety-five percent of the money goes to research supported by the foundation.

A: Why *ACQVA*? What is the meaning of the water?

FF: It represents life, and there is no life without love—so it represents love. And water is the symbol of sexuality—love and sex. It can lift you up or suck you down. It's something that surrounds you, that you have to live with and you have to deal with—and that can drown you. So it's soothing and scary at the same time.

A: Did you have any political feelings toward this project?

FF: Yes, of course. Actually, the whole thing started out of a mistake, a political mistake. I am Italian and have always been involved in politics in Italy. All my family were Communists, so we were brought up believing that the idea of a benefit is wrong, that when you do a benefit you withdraw from democracy—you allow the government to be less responsible to its people. You substitute yourself for what the government is supposed to be doing. So if the government is not doing the right thing, you don't do it—you get them to do it. You change the government. Which I still believe is right. This is how I was brought

up and what I always believed.

But when I came to New York, I had to face a reality, which is that we were always being asked to give the space at Industria for benefits, and I said fine. But one day I said, "I really want to know where this money goes," because in Italy, you have a problem with money that is meant to benefit—you never really know where it goes.

Well, I decided to visit a hospice in Harlem, and found myself holding two children with AIDS in my arms. You look at the children you're holding, and you say, "Okay, the government is supposed to do something for these children. But in the meantime, who is helping?"

I suddenly understood that there is a gap between the fight that needs to be done—the political fight, the social fight to get the government to take responsibility for caring for people with AIDS, for research—and the lives of these children, who may not outlive that fight. It is for this "meantime" that the idea of a benefit develops.

The one thing I said my group would not do was a benefit with costs covered. I have seen too many events where they spend a half-million dollars for a dinner, and everybody comes and says, "Oh, gorgeous food" and whatever, and have a lot of fun—and one hundred thousand dollars goes to research. Why don't you get the same people to pay the same amount of money to simply stand together for ten minutes—then six hundred thousand dollars would go to the research or the care.

A: Did any religious beliefs inspire *ACQVA*?

FF: Well, I am not religious myself. But I am a strong believer—I believe in things. I believe in human beings and the human spirit; I believe in the effort to improve the quality of our own life, and in the effort to help children. I say, "While we are alive, let's do all we can to make this a better world." I believe that we must help ourselves, each other, because nobody else will. Or even if someone will, there is always that meantime.

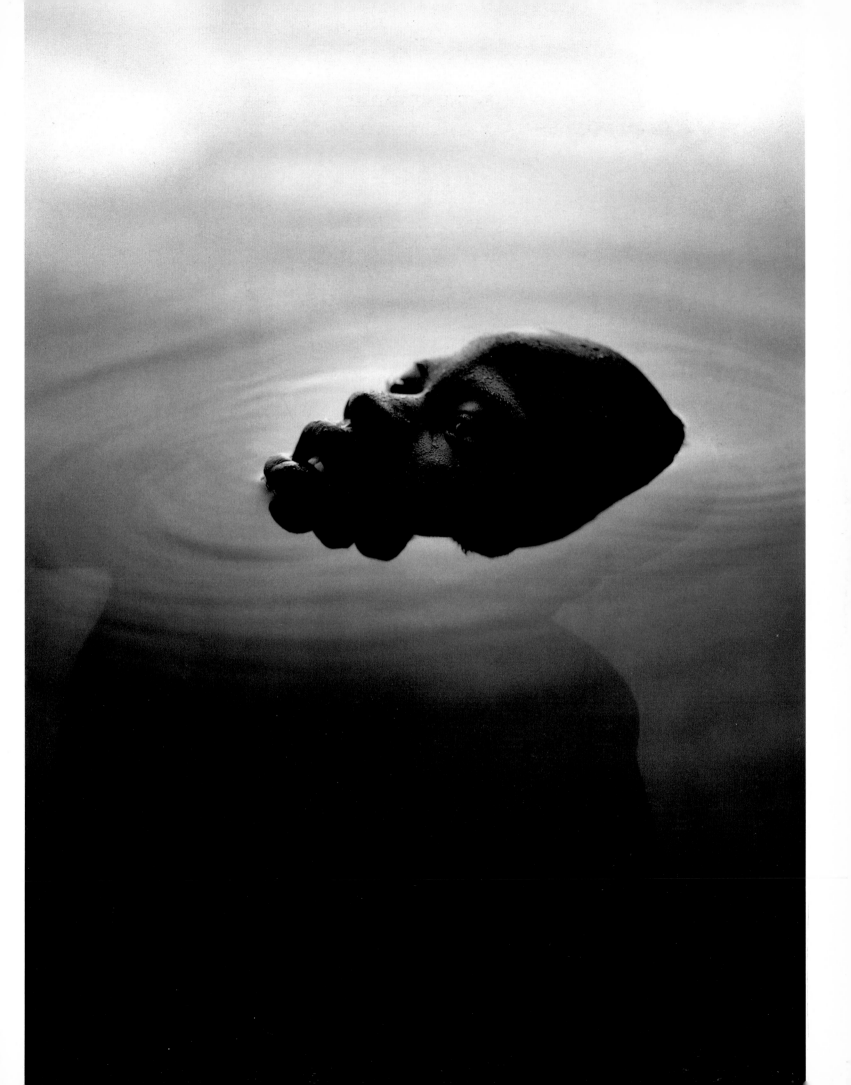

ADVERTISING, NAKED AND FULLY CLOTHED

By Furio Colombo

I WANT MY CLOTHES BACK

Luciano Benetton

UNITED COLORS OF BENETTON.

There are far more important issues in the world today than advertising images. But there is a fascinating relevance in photographer Oliviero Toscani's and Benetton's use of violent, sexual, wrenchingly provocative, drastic images. The word "drastic" comes from the same Greek root as the word "dramatic." Drastic action makes for compelling drama. Photography's realistic immediacy provides the same impact as a scene. The great playwright-poet Federico Garcia Lorca maintained that "The eye is the processor of the senses."

The current controversy is over whether Benetton's excruciating images (the young man dying of AIDS, the woman whose despairing face is reflected in a pool of blood, the refugees clambering up the side of the rescue ship, the human bone brandished by the guerrilla—years before Somalia—the war cemetery, the flood in Bangladesh...) belong in the marketplace. In a world that turns on

an axis of communication, Toscani and Benetton feel they do.

Some serious observers have insisted, however, that employing photography of such powerful, often miserable, emotions is a pretty cynical and manipulative way to sell a jaunty line of gear—to young folk who, according to Benetton's critics, don't have a political bone in their heads. The critical bottom line is that the tragedies depicted in this reportage-turned-advertising have, ultimately, one message: "Buy my stuff."

Monsignor Giuseppe Pasini, a sophisticated media-wise spokesman of the Church, is the most ubiquitous sniper. He attacked Luciano Benetton in the February 12, 1993, issue of *Caritas Italia*, accusing the marketing genius of manipulating the public with a gross, tasteless use of shock, schlock, and shtick, for the sole purpose of selling. (What else are public relations about?) Pasini fulminates against this advertising campaign because it aesthetically betrays serious photography by a serious misappropriation of human misery, a travesty of the human suffering that is by and large the province of philosophy and religion.

Naturally, his insightful, vigorous counter-campaign has succeeded in drawing even more attention to the Benetton tactic, expanding its reach enormously. The moment the Monsignor opened his mouth, he automatically bought into Benetton's game. And when Pasini decided seriously, technically, to "review" the most recent Benetton image, he might as well have been on the Benetton public-relations payroll.

That recent Benetton image is of a nude man, and the nude man is Luciano Benetton himself. Without a stitch on, Benetton appeals to those who buy Benetton products to donate their used garments, which Benetton will arrange to recycle for use by the needy.

Friends and foes of Benetton and Toscani agree on one thing: the idea works. Both sides are talking and writing about it, doing everything except forgetting about it.

It may seem condescending to recycle used clothes for the poor. But for many young people, the only sign of the passage of time is not when the "old" garments wear out but when a fashion runs out—after a new

advertising blitz. Particularly in the case of Benetton wearers, I wonder whether the clothes would really be "used." Moreover, was the world of poverty ever cited in advertising before Benetton's ad? What matters is not what the poster says, but its effect. It forces us to remember (even if it ridicules Benetton, it's not a bad gimmick) that our comsumption occurs in a world where others have nothing. I'm not suggesting for a moment that this is Benetton's altruistic intention. Whether he intended it or not, the controversial advertisement attracts attention specifically to a realm where everything is usually sentimental and abstract. Here, at least, we may think of the warm sweater that other people don't have as we sensually touch our own. Benetton has made us take notice.

"What people will do just to sell!" Pasini says. I say people have always done whatever they could to sell; to sell means to produce, and to produce means to employ. The product must be sold or the cycle of invest, design, produce, sell, earn, reinvest, and create more jobs will abruptly discontinue. When we say "there should be more jobs," we are in a way saying "there should be more Benettons," maybe even bigger ones, capable of creating many more jobs, but with the same will to go through the entire cycle, including the bold-faced readiness to sell at all costs—instead of leaving the hard sell and the creation of jobs to others, elsewhere.

What exactly is wrong with Benetton's desire to sell at any cost? Did he violate anybody's feelings or rights in doing so, and if the answer to this is yes, does the campaign have a redeeming value that outweighs what might be perceived as its exploitative quality? Certainly photographs of death, of massacres, of the Mafia, of AIDS, are shocking as Benetton ads. They're shocking as journalism. Yet here, they're startling, and they're "out of context," out of line—linking the name of a product forever to a sad or tragic aspect of someone's very real life—someone who never chose to be a Benetton model. But if we look at the so-called "sociological" photography dealing with illness, the Mafia, and death, and see it in terms of the "UNITED COLORS OF BENETTON" series (all kinds of children and adolescents in every possible combination of colors, forms, expressions and attitudes) we can discern the ongoing comment.

A decision was made by Benetton at the beginning of the entire advertising program,

and this decision seems to be as follows: the product is intended for people, so let's depict people. If you consider Calvin Klein, Ralph Lauren, the Gap, and other big-volume manufacturers, the advertising solution appears to be the same. Good-looking people, young people, exposure of the body—and a few garments—an undershirt, a pair of jeans. But wait a minute. All the others are aimed at an exclusive universe, young women or young men arranged in sequences that are either vaguely erotic or oddly suggestive. Many of these images hint (implicitly, obliquely) at the rape or the subjection of the child-woman, or at her provocations, which the macho model is unable to resist.

Strangely enough, the erotic fantasist or rapist implications in young ready-to-wear ads has never given rise to objections. Even nudity of the early Nazi style has not caused a scandal. The rule seems to be: leave it to the imagination and we'll leave you in peace.

Luciano Benetton has chosen another approach. Little by little, with lots of color, suggestion, provocation, and fun, as well as a few discordant notes (like the black woman suckling a white baby), he moved closer to reality—ultimately embracing it. He began by suggesting that his clothes adorn a world of innumerable types, that under a Benetton shirt, the different skin colors are equal. The message really is not "I'll make you equal." The message is "you are equal." Benetton is not, however, naive enough to think that just because all people are equal means they will be treated as such. Now, he is forcing us to see the injustices, just at the point when we are least likely to think of others.

As an idea for an advertising campaign, it's not an ignoble one. And it's different, and much more humane than the other campaigns of topless girls, nude men, and cross-provocations that lead to the usual indifference. True, Benetton wants to sell. What else is new? And it's not a crime to force people's attention where it would not ordinarily go. In fact, the event of these images takes place outside the compartments into which we have secluded our lives. Just when we are busy with ourselves, with our bodies and our free time, images (even if they are appropriated only to create startling advertising) carry us away to other people and their tragedies. Is that so immoral?

I wish to thank Arnold Weinstein for his assistance with the translation of this text. – F. C.

A FORCED PERSPECTIVE:

Aerial Photography and Fascist Propaganda

By Karen Frome

Mass movements are usually discerned more clearly by the camera than by the naked eye. A bird's-eye view best captures gatherings of hundreds of thousands. This means that mass movements, including war, constitute a form of human behavior which particularly favors mechanical equipment.
 —*Walter Benjamin*[1]

In Italy during the 1930s, the objectives of strengthening national unity and creating a disciplined society instigated a program of internal colonization. Aerial photography became an integral part of the Fascists' campaign, and this new perspective offered a shift in perception that the regime exploited to support its goals.

Under the program of colonization, the Fascists relocated families primarily from densely populated urban areas to five new "rural centers" in the Agro Pontino region south of Rome. Since the time of Caesar's Empire, unsuccessful attempts had been made to drain the malaria-infested Pontino marshes, a task the Fascist engineers miraculously accomplished. The view from the air served to demonstrate the regime's efficiency at transforming a previously useless region into arable fields and habitable communities. Mussolini referred to the Pontino development as a triumph over "water and death." New towns were built in record time and seemed to rise up out of nothing. Rational planning principles and symbolic hierarchical relationships are most evident when seen from above. Fascist-party buildings generally surrounded the primary public space, while the church, the traditional focus of Italian planning, was relegated to a secondary piazza. In Sabaudia, one of the new communities, the road connecting the town to Rome terminates at the tower of the Casa del Fascio, indicating the power strata.

In addressing the Pontine inhabitants, Mussolini saturated his rhetoric with military metaphors: "I am your commander and you are soldiers...together we will fight and together we will win."[2] By 1935, Italy was waging real war in Africa, but in the Pontino developments the enemy was "nature and the skepticism of men."[3] In Africa aerial photographs determined troop advancements, while in the Agro Pontino they provided evidence of the Fascists' swift conquest of the land.

Fascist rhetoric inextricably bound the redemption and cultivation of territory to the redemption of its colonists. Fertility became the Pontino battle cry. The inscription on the tower of Sabaudia reads: "This land wants to be redeemed from its deadly sterility," alluding both to the region and to the Fascist notion of propagating its people. Agrarian values were intended to "give new fertility to the province, the country, and have demographic impact."[4]

Mussolini's statement, "War is to man what maternity is to woman" intimately linked the cult of war with that of fertility.[5] By promoting childbearing, the Fascists intended to provide themselves with a greater

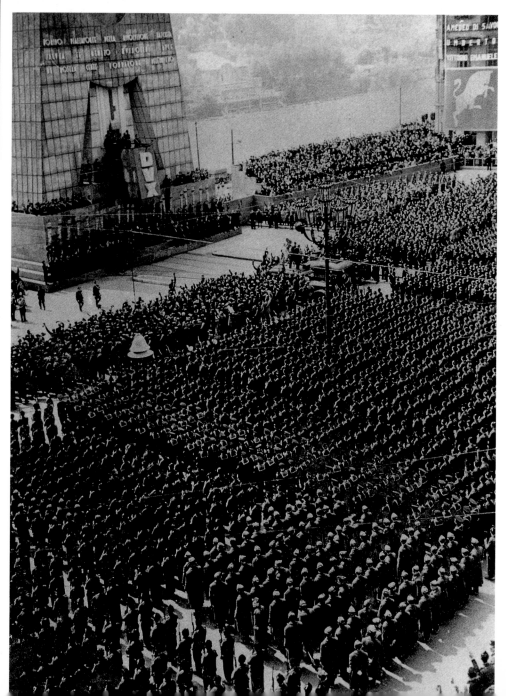

Mussolini giving a speech in Bologna, November, 1936

Aviation display for the inauguration of Sabaudia, 1934

pool from which to draw soldiers: "Mussolini wants the people to be prolific because numbers are power."[6] Children belonged to the national family with *Il Duce* as the symbolic father figure. Bringing full circle the relationship between war and fecundity, Mussolini called on pilots to vigilantly safeguard the fertility of the fields.[7] *Il Duce*'s various personae, from warrior to paternal caretaker, all alluded to the dictator's panoptic eye, which surveyed from an unobstructed vantage point.

Techniques of aerial photography originally developed in response to the strategic necessities of war. In World War I, aerial photographs became essential to keeping pace with the constantly changing configurations of battlefields. The aerial perspective, like that of the cartographer, objectifies the target, making mass destruction psychologically viable. Yet, unlike the mapmaker's projections, the photograph could claim to present a total and up-to-date view, encompassing all the details of human habitation.

As the first artistic movement to aestheticize war and the airplane, futurism recognized that the machine made it increasingly possible to achieve domination over what lay in one's field of vision. In 1934 the futurists devoted a section of one of their publications to "Il Duce Aviatore," featuring Mussolini as pilot and symbolically giving him domain over all he could see.

Early in his political campaign Mussolini appropriated the futurists' ethos of war and flight, as well as their revolutionary dissemination techniques. As a master of military and political strategies, *Il Duce* recognized that an image could have as much impact as bullets or bombs. The artificial re-creation of "real" events for photos and cinema became a major strategy of the Fascists in both Italy and Germany. Their meticulously choreographed ceremonies presented a well-ordered and united society. In a country still struggling with the process of unification, Italians could see their new national family depicted in an aerial "portrait," strengthening patriotic sentiment. Fascist spectacles became seductive, participatory demonstrations that in Benjamin's words brought the masses "face to face with themselves."[8] The aerial perspective best captured the desired effects of the Fascist ceremonies.

Before its use as a military reconnaissance technique, the aerial view had been available only to the celestial eye of God or through imagined and/or constructed depictions by artists and cartographers. The aerial perspective also inverted the subordinate role traditionally imposed in church— the upward gaze toward the dome of heaven. Soaring vicariously above the earth, man could now imagine that he could control all that lay below.

1. Walter Benjamin. *Illuminations*. (New York: Schocken Books, 1968), p. 251.
2. Benito Mussolini from his speech for the inauguration of the Province of Sabaudia, August 5, 1933.
3. Mussolini. Inauguration of the Province of Littoria. December 18, 1934.
4. Sergio Nannini. "Migrazione e Colonizzazione" in *L'agro Pontino*. Opera Nazionale dei Combattenti, 1940.
5. Mussolini as quoted in Max Gallo: *L'Italie de Mussolini*, p.308. Attributed to May 26, 1934.
6. *Telegrafo*. Livorno, April 6, 1932.
7. Mussolini, in *Opera Omnia*, vol. 29, p.197: "so the workers in the fields can make the land increasingly fertile, vigilance and protection must be in the skies of the homeland."
8. Benjamin, op. cit.

CONTRIBUTORS

CARLO BERTELLI was formerly director of the Brera Art Gallery in Milan. At present he is professor of Medieval and Renaissance Art at the University of Lausanne. He has taught widely in Europe and America, and has published extensively on medieval and Renaissance art. He is a member of the Restoration Panel for the Sistine Chapel and was formerly inspector of the Istituto Centrale del Restauro. He recently published a book on Piero della Francesca with Yale University Press.

GIOVANNA CALVENZI is a writer and editor who has worked on numerous Italian publications. Formerly editor in chief of *Lei*, director of photography at *Vanity Fair*, and picture editor for the fashion magazine *Amica*, Calvenzi now works as picture editor at *Moda*. She has also taught courses in the history of photography and has been involved with several books and exhibitions on the subject. She is extremely active in the field of contemporary photographic research.

FURIO COLOMBO, the Sanpaolo Professor of International Journalism at the Columbia University Graduate School of Journalism, is the author of several books on journalism and communications, and a columnist for the Italian daily *La Stampa* and the weekly *Panorama*. In 1972 Colombo published *The Chinese*, a photo-reportage about the Cultural Revolution in China (Hachette, Paris/Grossman Publishers, New York). He is currently the director of the Italian Cultural Institute in New York.

VINCENZO CONSOLO, born in the Messina province of Italy in 1933, has lived in Milan for the past twenty-five years. He is the author of many novels and short stories, notably: *Il sorriso dell'ignoto marinaio* (The smile of the unknown sailor, 1976), *Retablo* (1987), and *Le pietre di Pantalica* (The stones of Pantalica, 1988). His most recent novel, *Nottetempo, casa per casa* (During the night, house by house, 1992) won Italy's prestigious Strega award. Consolo writes for several newspapers and magazines, and his works have been translated widely.

PAOLO COSTANTINI teaches at the Universities of Venice and Milan. He is the author of *"La Fotografia Artistica" 1904–1917: Visione italiana e modernità* (1990), and the editor of the Italian edition of Heinrich Schwarz's *Arte e fotografia* (1992), as well as several exhibition catalogs, including *L'insistenza dello sguardo: Fotografie Italiane 1839–1989* (1989). He is a consultant and editorial coordinator of Fotologia.

Journalist and writer MASSIMO DI FORTI is the editor for cultural affairs of Rome's daily newspaper *Il Messaggero*. Formerly a contributing editor at *Vogue* and *L'Espresso*, his articles include "Fourier and the architecture of social happiness" and "The post-erotic society." He has curated several photo exhibitions, among them "Bellissime" and "Fashion and Spot."

DARIO FO is a playwright, performer, and director whose works have been translated and presented throughout the world. Among his best-known plays are *Mistero Buffo* (Comic mystery play, 1969) and *Morte Accidentale di un'Anarchico* (Accidental death of an anarchist, 1970). *Johan Padan e la Descoverta de le Americhe* (John Padan and the discovery of the Americas) was written in 1991.

KAREN FROME is an architect who received a Fulbright grant to work in Rome. Her research focuses on the town of Sabaudia and the Agro Pontino development in Italy's Latina province. She is pursuing a doctorate in architecture at Princeton University, and has a master's degree in architecture from Columbia University.

RON JENKINS's translations of Dario Fo's works have been produced by the American Repertory Theater, the Yale Repertory Theater, and on Off-Broadway in New York City. He has written for the *New York Times*, the *Village Voice*, and a number of theater journals. A Sheldon Fellowship from Harvard University enabled Jenkins to spend a year with Fo in Italy, and to direct Fo's plays in Lithuania, Israel, and the United States.

ANTONELLA RUSSO is curator of the Department of Photography at the Castello di Rivoli Museo d'Arte Contemporaneo, in Turin. She studied the history of photography in the U.S. under Beaumont Newhall, and has taught the subject herself, in the Education Department at New York's Museum of Modern Art. From 1987 to 1988, she was curator at the Elizabeth and André Kertész Foundation and at the Mission Photographique du Ministère de la Culture in Paris. In 1989, she received a Samuel H. Kress Foundation Fellowship for her research in Kertész's work, and more recently won a Cartier Foundation grant for her work in contemporary photography. She was the curator of last year's exhibition of the photographs of Mario Giacomelli at the Castello di Rivoli.

ROBERTA VALTORTA is a critic and editor who writes frequently about art and photography. A native of Milan, Valtorta started work in photography in 1976, as an editor at the magazine *Progresso Fotografico*, and subsequently at the Italian edition of *Zoom*. She is involved with the organization of two public archives: the Architecture and Landscape Photography Archive of the Province of Milan, and the Social and Anthropological Archive of Regione Lombardia. Since 1984, she has taught photographic language at the Centro Formazione Professionale Regione Lombardia in Milan.

LINA WERTMULLER is a world-renowned filmmaker. She is best-known in the United States for her films *The Seduction of Mimi* (1974), *Swept Away* (1975), and *Seven Beauties* (1976). Her more recent productions include *Sabato, Domenica e Lunedì* (Saturday, Sunday and Monday), starring Sophia Loren (1990), and last year's *Io speriamo che me la cavo* (I hope I make it).

CREDITS

Unless otherwise noted, all photographs are courtesy of, and copyright by, the artists. Cover photograph by Mario Giacomelli, from the series "Io non ho mani che mi accarezzino il viso," 1962–63; p. 9 toned print by Giuliana Traverso, 6 x 8½"; pp. 10–11 watercolor and ink-jet printing by Francesco Clemente, courtesy Galerie Bruno Bischofberger, Zürich; p. 13 colored ink and watercolor drawing by Dario Fo, 1991, courtesy Dario Fo and La Comune, Milan; pp. 16 and 19 photographs from "Cent'anni di Vaticano dall'Archivio Felici," courtesy Il Diaframma - Kodak Cultura, Milan; pp. 20–25 all photographs by Velio Cioni, Tazio Secchiaroli, and Sergio Spinelli, courtesy Roma's Press Photo, Rome; p. 26 Polaroid by Paolo Gioli, ca. 16 x 12"; p. 27 photogram by Luigi Veronesi; p. 28 Polaroid by Paolo Gioli, 19¼ x 26¾"; p. 29 Polaroid with cord, cardboard, and staples by Natale Zoppis, ca. 12⅝ x 9"; p. 30 Polaroid by Franco Vaccari, 3¹⁵⁄₁₆ x 5¹²⁄₁₆"; p. 31 Cibachrome print of pinhole photograph by Paolo Gioli, ca. 39⅖ x 51⅕"; p. 35 photograph by Paolo Monti, courtesy Istituto di Fotografie Paolo Monti, Milan; p. 36 triptychs by Davide Mosconi, ca. 54⅗ x 81⁹⁄₁₀" each; pp. 40–43 photographs by Ugo Mulas, courtesy Archivio Ugo Mulas; pp. 44-45 and p. 46 photographs by Olivo Barbieri, 22⅗ x 39"; pp. 47–48 photographs by Luigi Ghirri, courtesy Archivio Luigi Ghirri; p. 59 photograph by Ferdinando Scianna, courtesy Magnum, New York; p. 63 photographs by Ferdinando Scianna, courtesy Magnum, New York; p. 71 photograph by Anton Giulio Bragaglia, courtesy Gilman Paper Company Collection; pp. 76–77 photographs courtesy Archivio dello Stato, Rome; p. 74, left, photograph by Oliviero Toscani, Spring 1993 campaign; p. 74 right, top to bottom, photographs by: Therese Frare, Spring 1993 campaign; Yves Gellie, Odyssey Images, Paris, Fall 1992 campaign; Steve McCurry, Magnum, New York, Fall 1992 campaign; Oliviero Toscani, Spring 1991 campaign; Patrick Robert, Sygma, New York, Spring 1992 campaign; p. 75 top to bottom; Oliviero Toscani, Fall 1989 campaign; Steve McCurry, Magnum, New York, Spring 1992 campaign; Oliviero Toscani, Fall 1991 campaign; Lucinda Devlin, Fall 1992 campaign; Franco Zecchin, Spring 1992 campaign.

NEW
INTELLIGENT
AUTOMATION

The new Leica R7 represents a breakthrough in photo-electronic technology, incorporating the most accurate and versatile autoexposure/ autoflash system ever developed. Utilizing precise TTL half-stop metering and uniquely "intelligent" microprocessor-controlled software, the R7 is capable of producing "perfect" exposures under an extremely wide range of shooting conditions. Of course you also get unmatched R-series lens optics and precision Leica craftsmanship, all backed by Leica Camera Inc.'s exclusive no-fault Passport Protection Plan.

To learn the full potential of intelligent automation, see the new R7 at your authorized Leica Camera Inc. Dealer. Call 1-800-222-0118 for the names of the ones nearest you.

Leica
...more than a camera.

Leica Camera Inc., 56 Ludlow Avenue, Northvale, NJ 07647
In Canada: Leica Camera Inc., 2900 John Street, Suite 2B, Markham, Ontario L3R 5G3 ©1992

VISION *Editions*

Flor Garduño
Witnesses of Time

edition of 40 portfolios
10 images
8" × 10"
(exclusive US distribution)

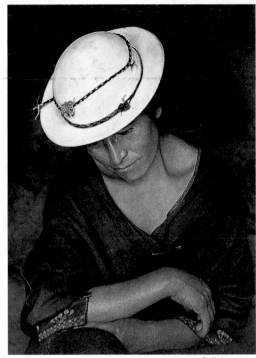
Virgen, Bolivia, 1990

A continuing series of limited edition platinum/palladium prints and portfolios

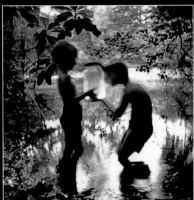
Fireflies, 1992

Keith Carter

single print
edition of 30
10" × 10"

Perspective II, 1967

Ruth Bernhard

edition of 40 portfolios
10 images
4 1/2" × 5 3/4" to 4 1/2" × 8 1/2"

VISION GALLERY • 1155 Mission Street • San Francisco, CA 94103 • (415) 621-2107 fax (415) 621-5074